FOR THE L♥VE OF
GREYHOUNDS

FOR THE L♥VE OF
GREYHOUNDS

Adopted Greyhounds
and their Happy Ever Afters

ALEX CEARNS

ABC
Books

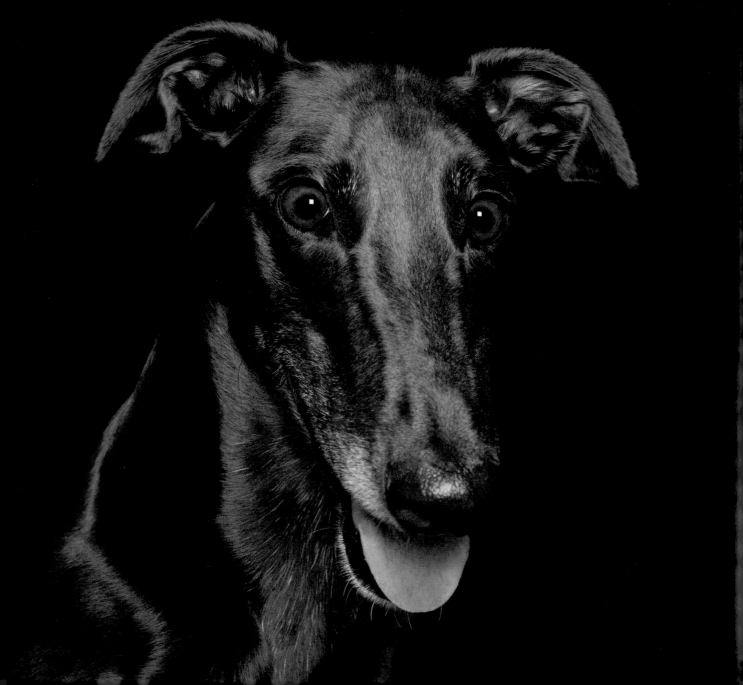

To Pixel.
Loved you at first sight.

The origin of the majestic greyhound dates back hundreds of years. Often depicted in paintings as sophisticated and regal, art definitely does imitate life. Since the rise in adoption of retired racing greyhounds, more Australians are choosing to adopt these beautiful, docile dogs into their homes and hearts. They recognise their elegance, gentle natures and comical personalities, and fall in love with the breed.

Greyhounds are lovely dogs and make fantastic pets. They are couch potatoes who enjoy nothing more than lounging around, and they generally don't require a lot of space or a huge amount of exercise. They can also be addictive – it's hard to stop at adopting just one.

When my partner and I adopted a rescue kelpie x greyhound puppy named Pip just over six years ago, we found her to be a loving dog. We didn't hesitate when we were later offered an opportunity to add to our fur family, and adopted a young greyhound puppy, named Pixel, from Brightside Farm Sanctuary in Tasmania. Pixel's formative months were spent in the company of pigs, sheep, rabbits, dogs, cats, chickens, cows, turkeys and ferrets. They were her playmates and first friends.

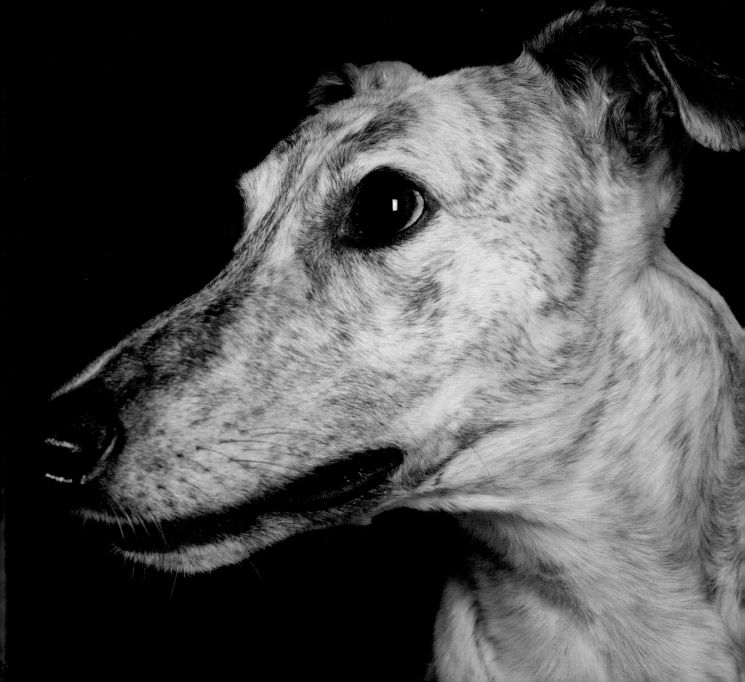

INTRODUCTION

Potential greyhound parents often wonder if greyhounds can get along with other pets and animals. Many greyhounds can cohabit with other pets very well. Prior to a greyhound being adopted, each one is temperament tested by their relevant rescue organisation and is placed into the most suitable home based on their test results. Many first-time greyhound adopters later wonder what took them so long to discover the delight in living with a grey.

Pip and Pixel both have gentle loving natures typical of greyhounds. Pixel is an absolute joy to live with. She is a bit of a clown, with a cute and cheeky sense of humour, and delights in making as much noise with her squeaky toys as she can. She loves her cat sister, Macy, and her best friend is her big sister Pip. I'm so thankful that the chance to adopt Pixel came to us, and that we were able to join the unofficial club of people enraptured by this adorable, quirky breed.

Dispelling the myths about greyhounds is important to me and I am keen to spread the word about these sensitive souls through their images and stories. It's no secret that they are my favourite dog breed, and I wish for more and more people to discover the delightful value they can add to our lives.

Please enjoy *For the Love of Greyhounds.*

Alex Cearns

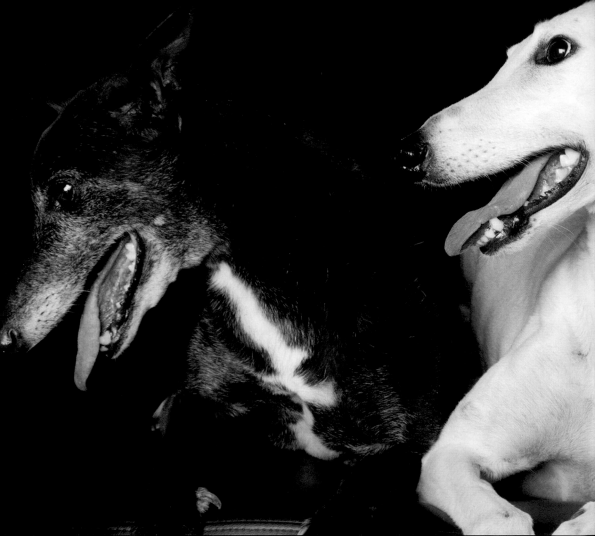

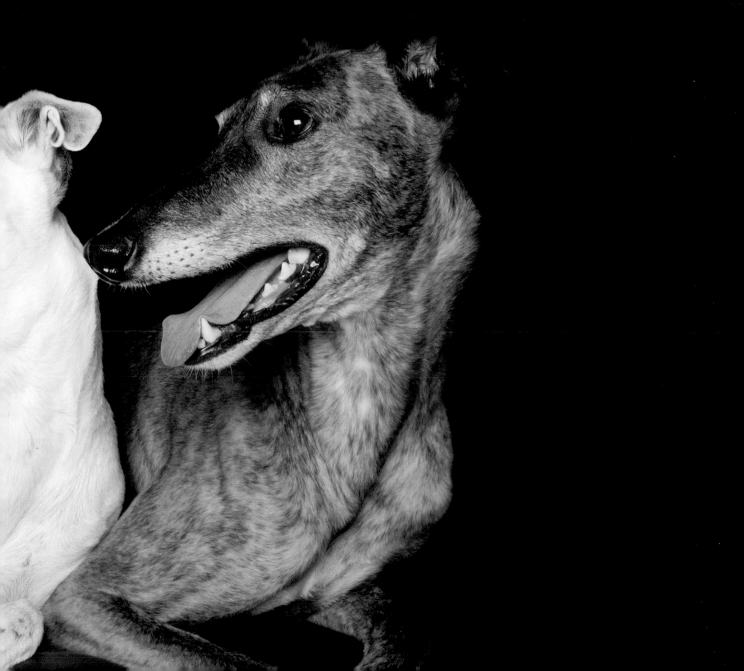

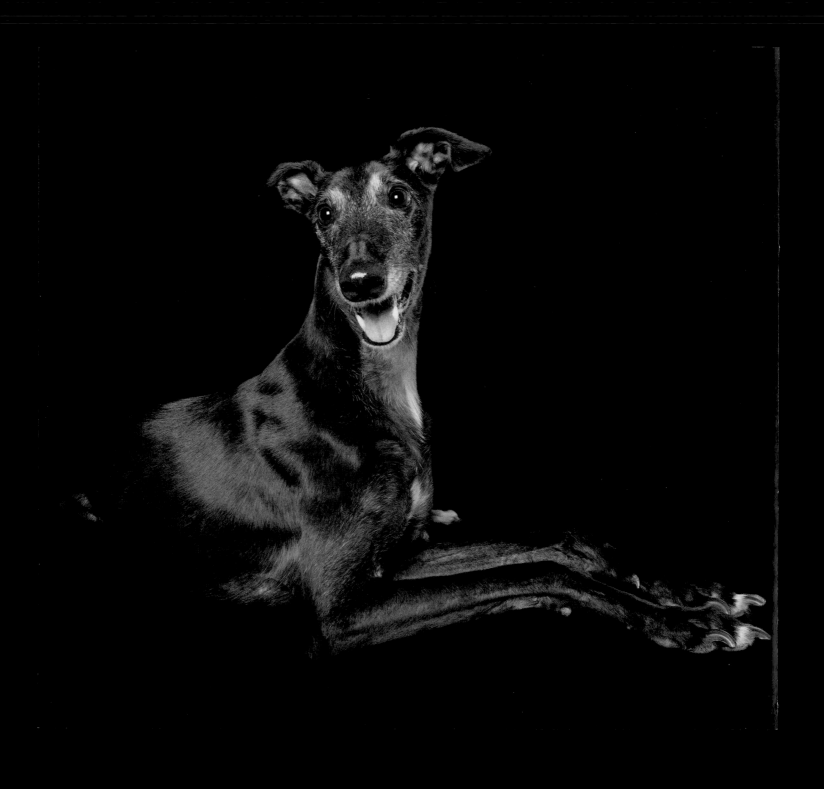

BARBIE

2 years old

Human:
Jet

One of Barbie's nicknames is 'Queen Victoria'. She is regal and sometimes demanding. Barbie will make sure I know if her water bucket is empty. She likes to be in the same room as me, but with her own physical space. Barbie does not like to be smothered. If another dog is in her spot, she will protest loudly until I come and shoo them away. Occasionally, if she thinks no one is looking, she'll let her hair down and do a few quick zoomies around the room.

Barbie is perfect on the lead and handles all kinds of rude dogs with aplomb. Once, two large, angry, off-leash dogs confronted us in a remote beach car park. They rushed up to Barbie, hackles raised. I thought I was going to have to fight them off. However, she handled it in true aristocratic style: with just a glare, Barbie convinced them both to back down.

As soon as I adopted a greyhound, my social circle doubled in size. I was inducted into a new world of group walks and doggie dates. Greyhound owners jokingly refer to it as a cult, complete with its own lexicon.

I love having dogs that I can take out to cafés and that are happy to sleep most of the day, yet leave me awestruck every single time they run. They don't shed, they hardly smell; they really are the perfect pet.

13

MOUSE

2 years old

Human:
Jet

Mouse is the opposite of Barbie in almost every way; they are my Yin and Yang dogs. Her nickname is 'Little White Devil'. She often gives the impression that she's been taking uppers. I can't put my shoes on without her body-slamming me and trying to blind me with her tail, because she knows it means we're going out. Given space to run, Mouse will do her trademark bouncy gallop, where she expends more energy getting vertical than any horizontal motion. People call her 'the happiest dog in the world'.

When I adopted Mouse, she was 2 years old and needed hobbies. I found her lure coursing, where dogs chase a plastic bag attached to a string across a field. The dogs are given a score according to how well they course the bag, with the criteria being speed, endurance, enthusiasm, agility and follow.

Mouse is now a champion lure courser. At first, she was a handful to hold onto, thrashing and jumping in excitement to start her run. Now, at 7 years old, she walks calmly to the start and sits politely until it's her turn.

Mouse is also a champion cuddler. She knows just how to nestle into her humans to get optimum pats. She loves to sleep up against my legs or on my lap.

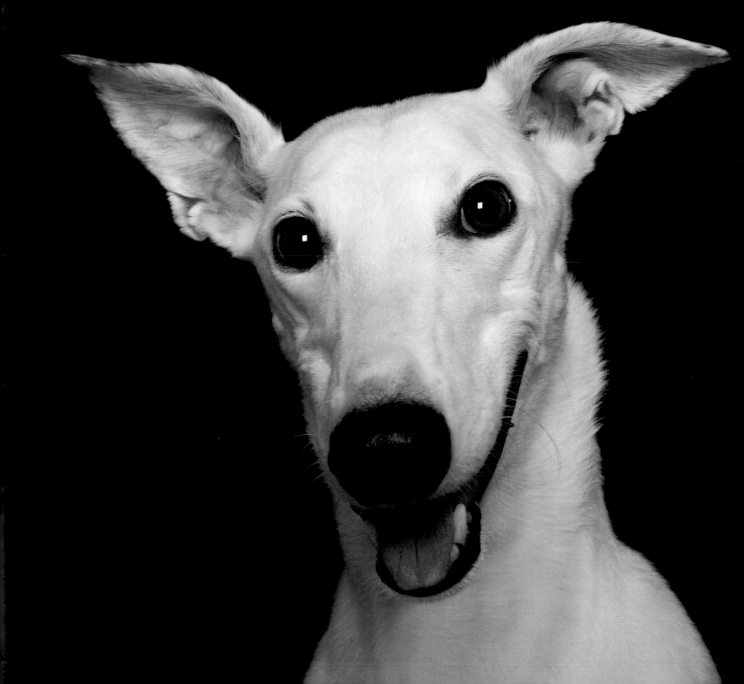

BRANDY

5 years old

**Human:
Cassie**

We have always loved greyhounds, so we started fostering them. They are just so sweet, gentle, quirky and fun to have around that we knew we had to adopt one.

Brandy is one of the nicest dogs you could ever meet. He loves affection, playing with his toys and going for walks. And he loves to talk when he is hungry or wants attention. At the same time, he is so calm that we've nicknamed Brandy 'the therapy dog'!

He has changed our lives. Brandy makes every day better, just by being there and making us smile.

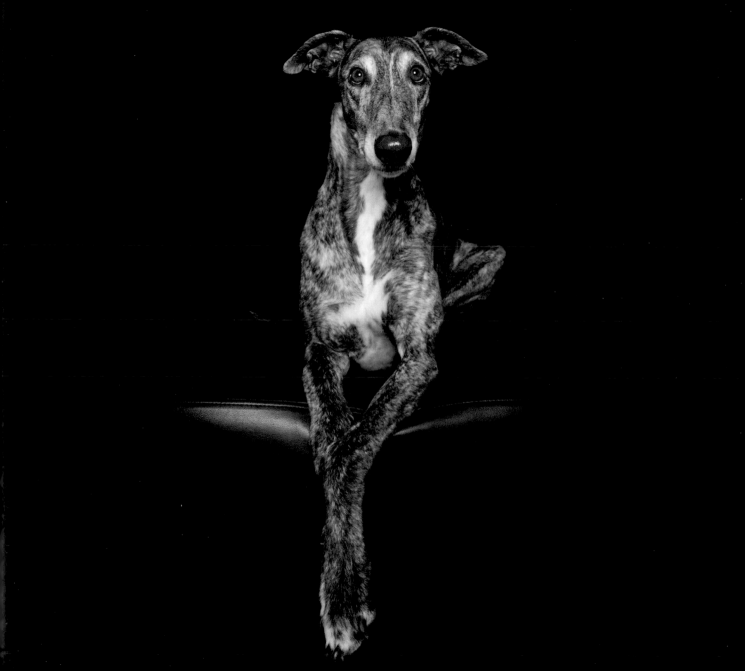

ROCKY

4 years old

Humans:
Holly & Richard

My partner and I had just moved into a house with a huge backyard. We wanted to share it with an older dog that would appreciate the space. We tried adopting a blue heeler x kelpie, but the adoption agency knocked us back – that dog needed a family with children. A friend then recommended greyhound rescue.

Rocky was bred for racing but he was not suitable. Luckily, his owner didn't euthanize his dogs, so Rocky grew up with his brothers and sisters in a kennel run. We ended up adopting him at the age of 4. He had a rocky first few months with us while adjusting to his new world. However, he can now sleep through anything: the sounds of washing machines, fans, car horns and so on are all the norm.

Rocky makes us laugh every day. Roaching (lying on his back with his legs at all angles), derping (hanging his tongue out of his mouth absentmindedly), downward dogs with a raspberry fart and zoomies are just some of the things you will experience with a greyhound.

Although sleeping is usually high on Rocky's agenda, he also loves going to the park for walks. This gets my husband and me out of the house for fresh air and we catch up on each other's day.

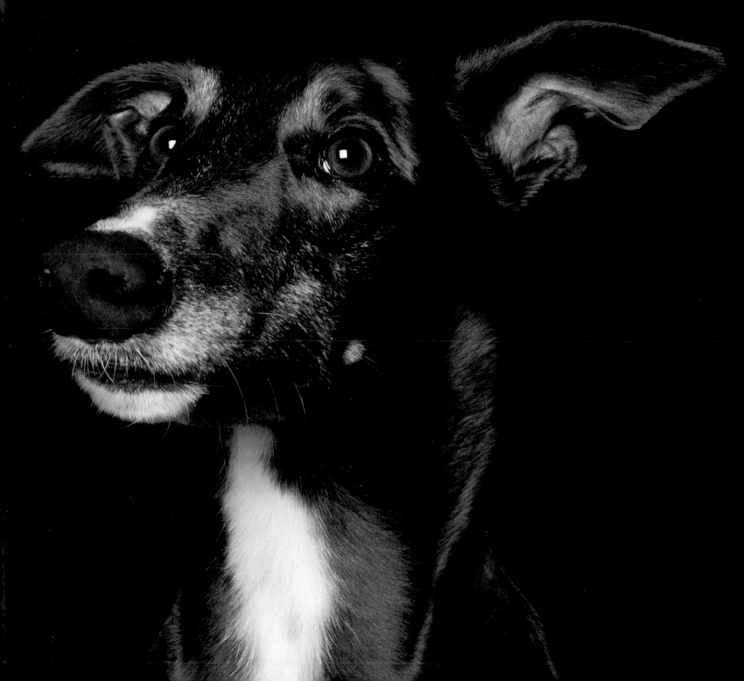

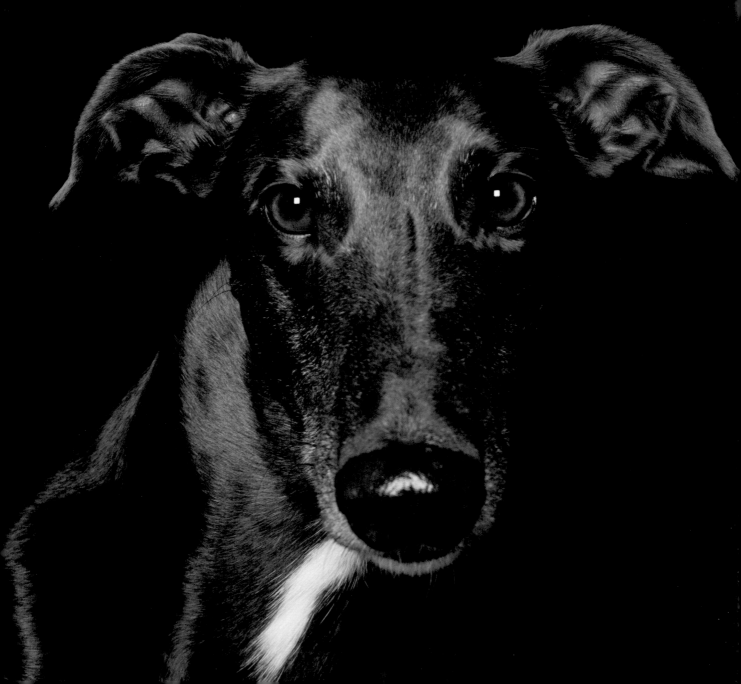

BROCKY

4½ years old

**Human:
Sue**

As a lifelong 'dog person', I decided that my next companion should be a rescue dog. Greyhounds were never at the top of my list, but my friends' greyhound Rocky changed my mind with his quirky ways. To begin with, I fostered Brocky. It didn't take long for the relationship to move from mere fandom to love for my tall, dark and handsome man.

Brocky has character plus, with extra toppings. When it is hot, he loves being hosed down in 'his' paddling pool and asks for 'his' air conditioner to be turned on. When it is cold, he gently wakes me up and recommends that 'his' throw be put on. He loves perfume and rubs his face all over me when I'm wearing it. If he meets a perfumed stranger on a walk, he will shamelessly show the same appreciation. Likewise, he can remember from several years past where he saw a cat.

Brocky has made me fitter. He takes me for a good 40- to 60-minute walk every morning, which improves not only our physical and mental health, but our general wellbeing, too.

I will never tire of viewing his walking gait, proud and prancing, his ears erect with vigilant awareness of his owner. Brocky has given me so much love and affection. He makes me incredibly happy.

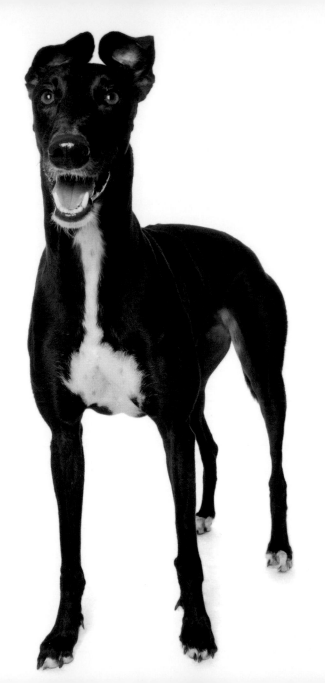

BRUCE

3 years old

Humans:
Daniel & Carol

Bruce came to us as a big, boofy, mistreated, starved and sorry-looking boy. He was more flea than hound, a situation helped by the amount of fur he was missing. Bruce also had a broken paw, which needed to have a toe amputated – infection had set in because it wasn't treated. Off the toe came and we finally got to see him in full-flight greyhound-running glory.

Not long after we adopted Bruce, my dad John's cancer returned. Bruce sensed his pal was sick. On a normal walk, Bruce would bounce off the walls. With John, he would walk at a slow, gentle pace and not once pull on his lead. When John was sick from treatment, we'd find them curled up together on the floor. Bruce was with John through the final days and brought him comfort and peace when nobody else could.

When I was pregnant, Bruce would snuggle up with me and place his big head on my stomach. And now that his skin brother is here (little John), it's Bruce's mission to make sure he is safe.

Bruce is who I turn to when days are tough or life gets me down. He has changed our lives by giving so much love to all of our family – a gift Bruce gives freely, despite the horrific treatment he suffered before he came to us.

BUDDY

4 years old

Human: Michelle

I had wanted a dog for years. When my husband, Jase, was off work with an injury, he saw Buddy waiting out the front of the local shops for his foster mum, so Jase (and the milk) waited with Buddy, too. That was the start of a new chapter for our family.

Buddy was the happiest, biggest, most uncoordinated clown. He had the widest smile. And he truly thought he was a lap dog. There was nothing Buddy liked more than being on the couch with his humans, having a cuddle. Buddy loved people, especially kids. A walk past the local school took forever because everyone wanted to pat the big blue dog.

Buddy was the epitome of the lazy greyhound, sleeping up to 18 hours a day on his double-bed mattress, with either his doonas or the air conditioner, whichever he needed. We did not realise just how stoic and strong he really was until he became terribly sick. During his last few days, my big, life-loving boy briefly lost his smile, but he still wagged that amazing tail and head-butted the door to his favourite vet on his special last trip.

Our lives are so much richer from sharing them with Buddy for those three wonderful years. Even though his time with us was cut short, we are so glad we met him. We had many laughs with Budster. Everyone just loved him.

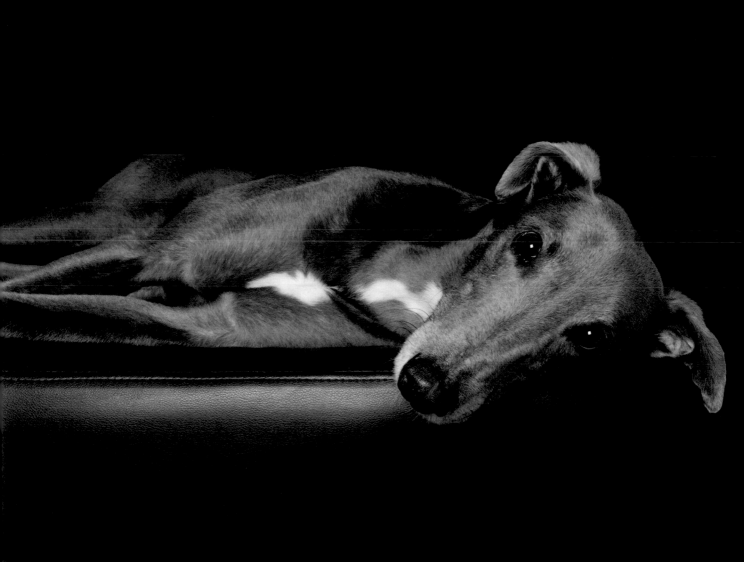

CONNOR

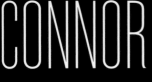

4 years old

Human:
Lisa

I'd wanted to get a dog for years, but I work full-time. Then I saw an ad for GreyhoundAngels, went to their website and was hooked. A greyhound seemed like the perfect dog for me: quiet, low exercise, able to be left alone while I was at work! I soon welcomed a giant white boy that I named Connor. And I've adopted four more greys since.

Connor, an ex-racer, was an amazing dog. He was kind, funny and friendly; he loved everyone. Connor was a supreme leaner, he specialised in sticking his head in people's bags without them knowing, and he was great at helping to calm anxious dogs. I had 10 beautiful years with Connor; he died peacefully at home in his bed. Broke my heart into a million pieces. I still forget that he's not here, and it's been just over a year.

My greys have impacted my life immeasurably. I have a depressive illness; they've gotten me out of the house and, at times, they've given my life a purpose when it didn't seem to have one (writing that feels melodramatic, but it's true). They've taught me tolerance, compassion and the importance of lying upside down, legs akimbo under the air-con. They've inspired me to help end greyhound racing in Australia. Most importantly, they've given me a deep, great love, a love that I don't think I'll ever be able to replicate.

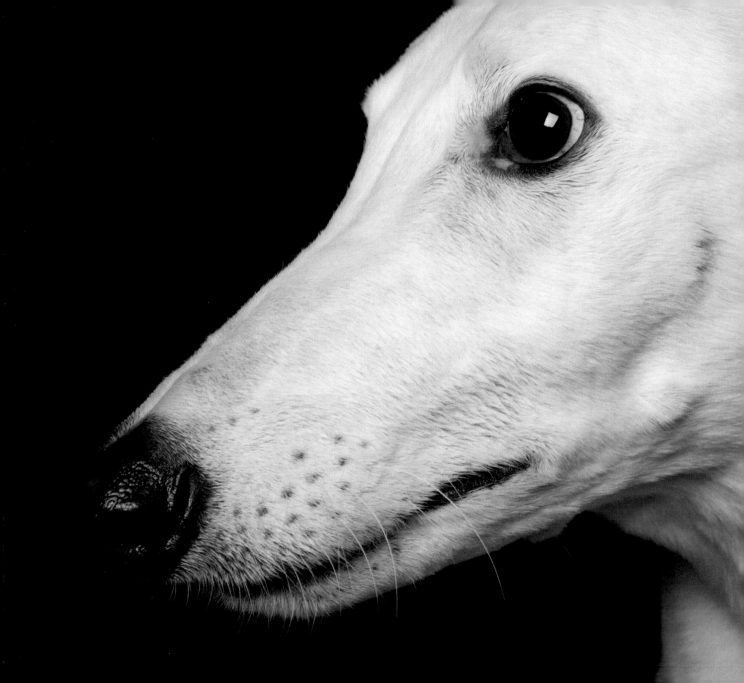

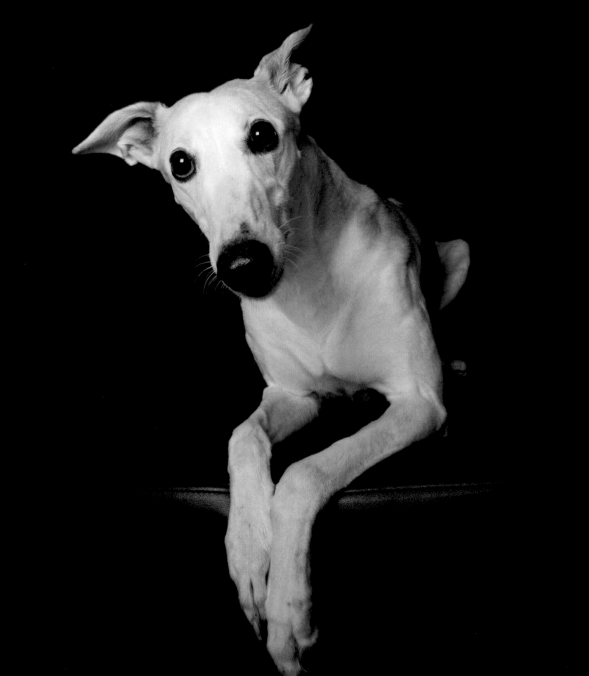

ELLY

4 years old

**Human:
Lisa**

Elly was an ex-racer; she was a completely different dog to Connor, my first grey. She was bouncy and smiley and naughty. She loved to play. Elly would try and entice Connor into playing with her, but he rarely would. He was more of a lounger – haha.

Elly loved Connor from the moment they met; her tail nearly wagged off whenever she saw him, it was lovely to watch. They both loved people, so we'd often go for long walks around Fremantle or Rockingham, along the beach where they could meet loads of people and soak up the attention.

They loved to share an ice cream and they'd even get their own on special occasions. We all enjoyed going to one of the many dog-friendly cafés around the city.

Elly passed away suddenly and unexpectedly at the age of 13. Luckily, it was quick; it only took a minute, maybe two, but I don't think I'll ever forget going into my bedroom and finding her. I'm just thankful that I was able to hold her as she died. I'm glad that she wasn't alone. She's so missed.

SAXON

3 years old

Human:
Lisa

Sax never raced. He was meant to be a foster only – that status lasted all of 30 seconds. Sax had severe anxiety and would completely trash the house every day when I went to work. The vet put him on medication which, along with training, worked a treat. Eventually, he was able to come off it.

Sax is the sweetest soul you'll ever meet. He is shy, smoochy and snuggly when he knows you and when he's at home, but he can be quite reserved, verging on nervous, when he's out. It breaks my heart when I wonder how and why he came to be this way, because at home with me and with people he knows, he's a hilarious, affectionate goofball. But the minute a stranger appears, especially a male, he's a shivering, quivering, hiding mess.

Maybe it was a lack of socialisation when he was young? I hope so. The thought of it being something more sinister makes me very sad.

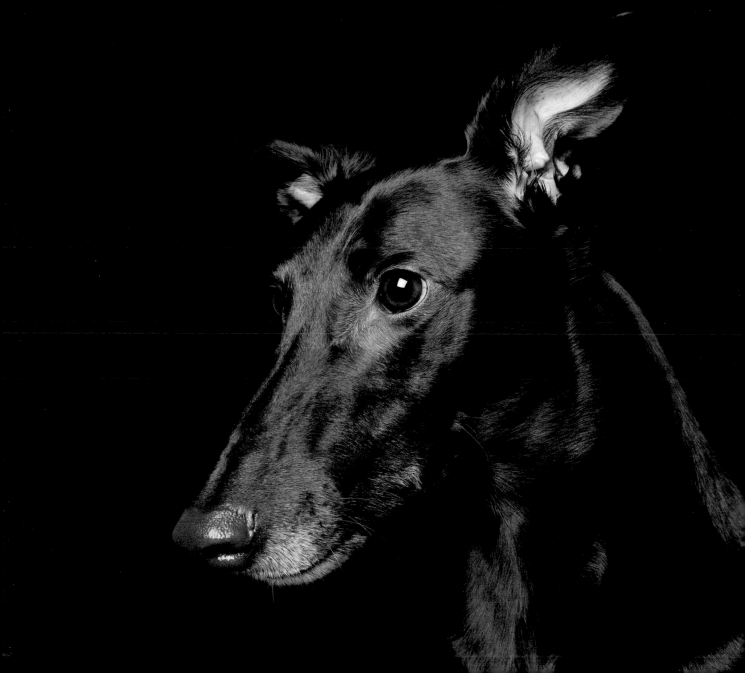

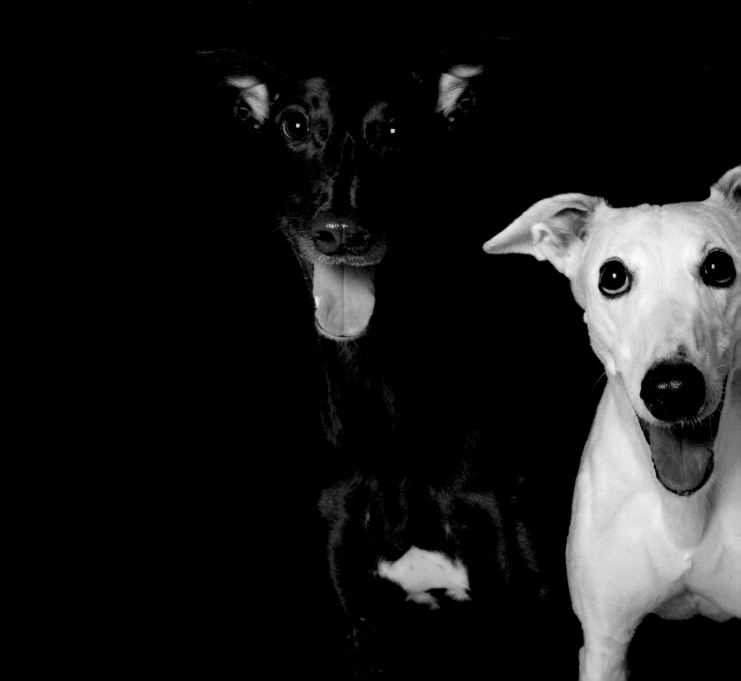

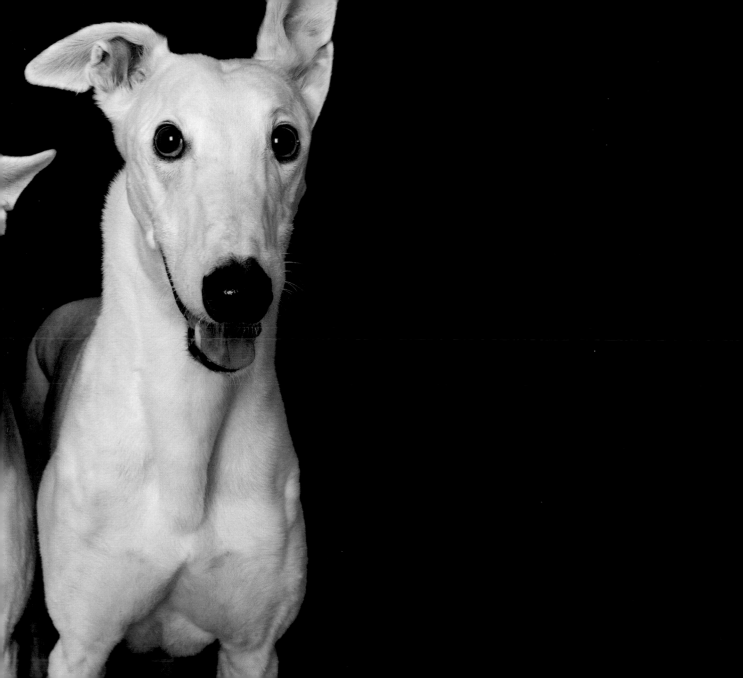

SPUD WITH DOZA

(Grey cross)

5 years old

**Human:
Sarah**

I didn't make a conscious choice to adopt a greyhound or greyhound cross. I saw Spud at the RSPCA in Malaga and just thought he was beautiful. He had been surrendered with another dog and the shelter staff were surprised he was still there. I like to think he was waiting for us.

Spud was the classic Zen dog; he was chilled out. He loved being at the dive shop every day, meeting and greeting all the customers. His favourite games were playing tug with his brother, Doza, and sneaking off down the lane to visit his Aunty Kathy when we weren't looking. Spud was really good with most other dogs and even had a cat friend, Misty, that lived next door. We loved him very much.

After Spud passed away, we decided to adopt another greyhound. We found Charlie through the wonderful Greyhound Angels. He has taken on the mantle of super-chilled, ultra-gentle nosy parker to a tee.

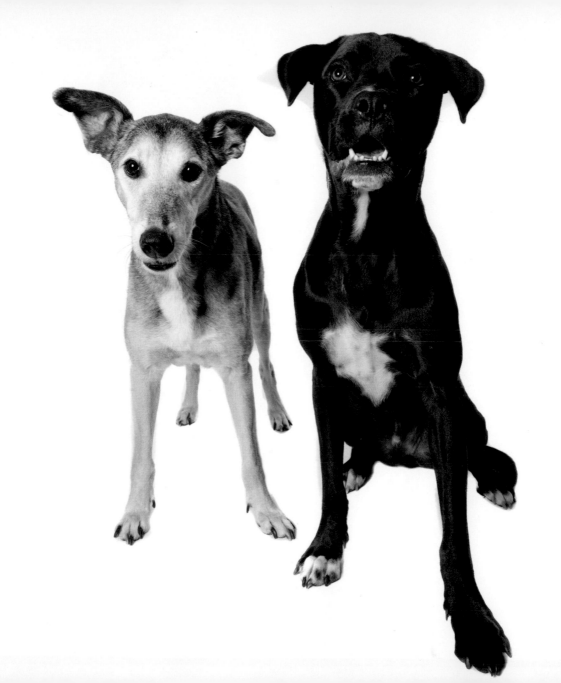

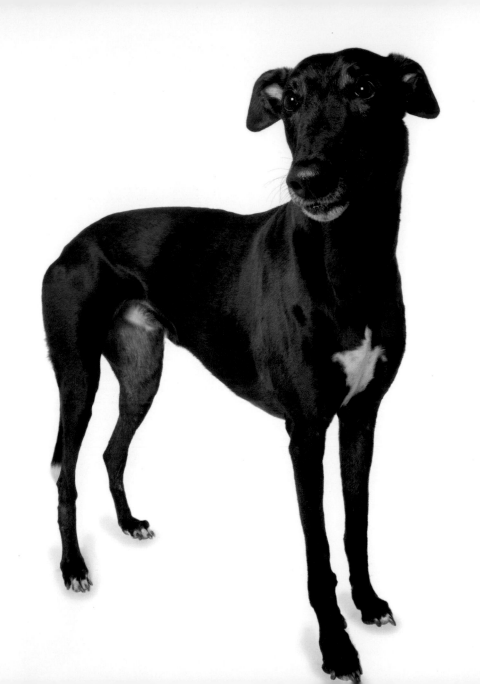

EMMIT

10 years old

Human:
Tracy

Emmit came into our lives because our German shepherd had passed away and our Maltese, Jack, was devastated by the loss of his companion. The vet suggested that we get another dog to help Jack with his grief. They felt a greyhound would be the perfect match, and they were right. Jack adored Emmit on first sight. We would always find them sleeping on the same bed or wandering around the yard together.

Emmit spent 10 years in a kennel before finding his forever home with us, so he is more reserved than most dogs. But don't be fooled. He loves affection and a good ear rub, long naps and lounging around. Although he is a gentle giant, Emmit gets excited when we have visitors – especially tradies – or if there is food nearby.

It has nearly been four years since he became a member of our family. We have laughed at his antics and loved watching him grow in his new environment. We have lost a number of flyscreen doors along the way – Emmit sometimes forgets that the door needs to be open before you proceed. Oh, and there is the new lounge that we had to buy because Emmit spent so many hours sleeping on the old one that it finally gave way under his 32 kg, but it was a small price to pay for all the joy that he brings.

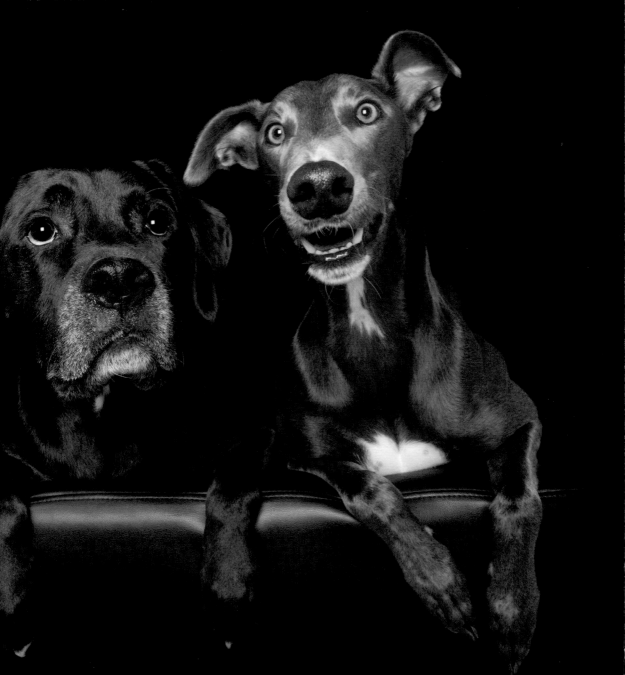

ALWYN WITH GARY

2½ years old

**Human:
Hannah**

We adopted a greyhound first and foremost because we wanted to save the life of one of these beautiful creatures. We also researched the breed and found that their sweet, docile nature would fit in perfectly with our family.

Alwyn is a gentle dork. He's cheeky and persistent but hasn't got a mean bone in his body. He is inquisitive and gentle with every person and dog he meets. His extra-long snoot also gives him the most hilariously cute overbite in the world. You just can't resist planting kisses on it.

Adopting a grey has filled our lives with so much joy. It's hard to imagine a time before Al was with us. Every day is filled with laughter, affection and fun.

GEORGE

7 months old

**Human:
Jennifer**

'Free to a good home. Greyhound. Seven-month-old. Female. Brindle.' This was the shopping-centre notice that brought me to George. When I met her, she was in a bit of a state, covered in mange and very skinny. The boy who'd owned her had wanted a roo dog and had picked her from a litter on the promise that she was a wolfhound. Not a chance.

George was the single constant in my life, from the day she jumped into the back of my car. She made wherever we were feel like home and, at times, was my reason to get out of bed. Totally loyal, George was the kind of dog that would look into your soul. That unsettled a few people over the years. She was sensitive and smart, and would do just about anything for food!

Sadly, George passed away recently. She died peacefully, surrounded by the people who loved her most and assisted by the staff at the animal hospital, whose compassion and kindness I will not forget.

I miss her. I hope I gave her a good life. It was through adopting George, and then her brother Gus, that I began to think hard about the industry producing so many animals that need rehoming. I hope that greyhound racing will soon cease in Australia. What a testament to the spirit of these animals, that they can still be so loving and loyal towards the humans who give them a second chance.

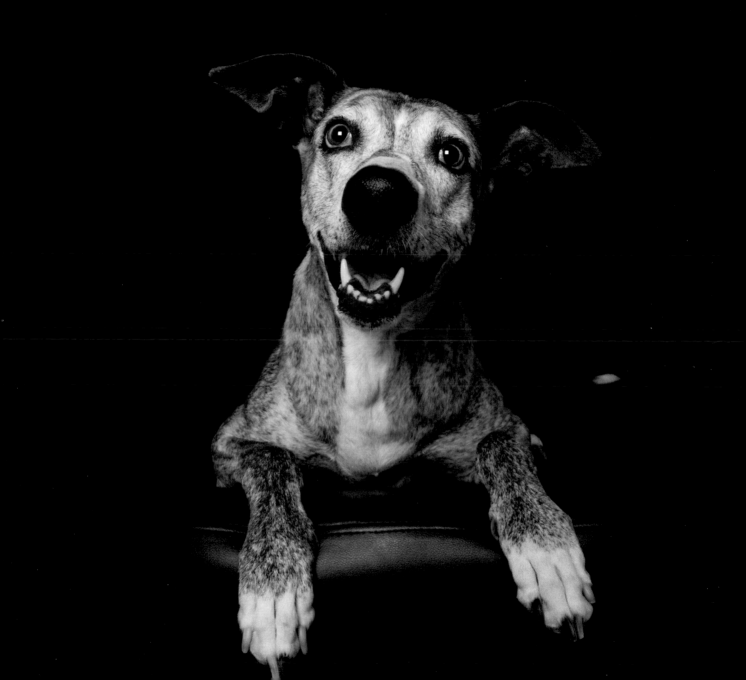

JACK

2½ years old

**Humans:
Chris & Ria**

A few days after we decided to get a dog, our neighbours adopted two greyhounds. We met their dogs and were sold! Jack came to us through GreyhoundAngels after spending a little time with his foster mum, Sheree.

We know little of his back-story, other than that he failed to make the cut as a racer – too slow. We believe his breeder mistreated him because of his scars and absolute fear of men, which we're slowly coaxing out of him.

Our first meeting with Jack was a short play date at our house. Sheree brought him around to see if he liked us and if we liked him. Within seconds, he raised a leg and christened our entry foyer. I guess that was his way of saying, 'I could live here. In fact, I'll mark it.'

Jack was nervous on the day he came to stay with us and pretty much avoided all the nice things we had for him. Except for an old stuffed hippopotamus we call Herbert. As the time neared for Sheree to leave, Jack bolted for the door, paused, returned to the lounge, grabbed Herbert by the scruff and pranced back to the door. 'Thanks for the toy, I'm going now.'

With time, Jack has settled into life with us, grown in confidence and become a happy boy. He has taught us how infinite love for a dog can be.

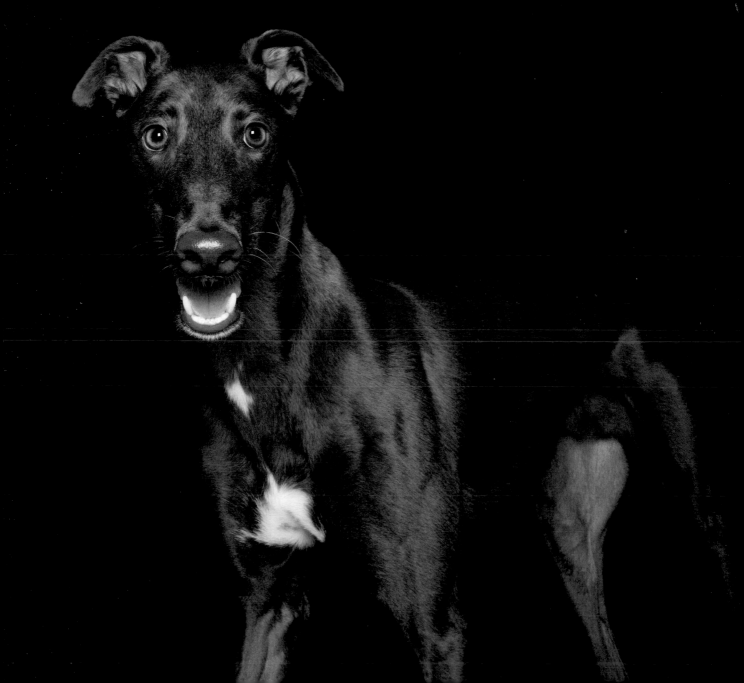

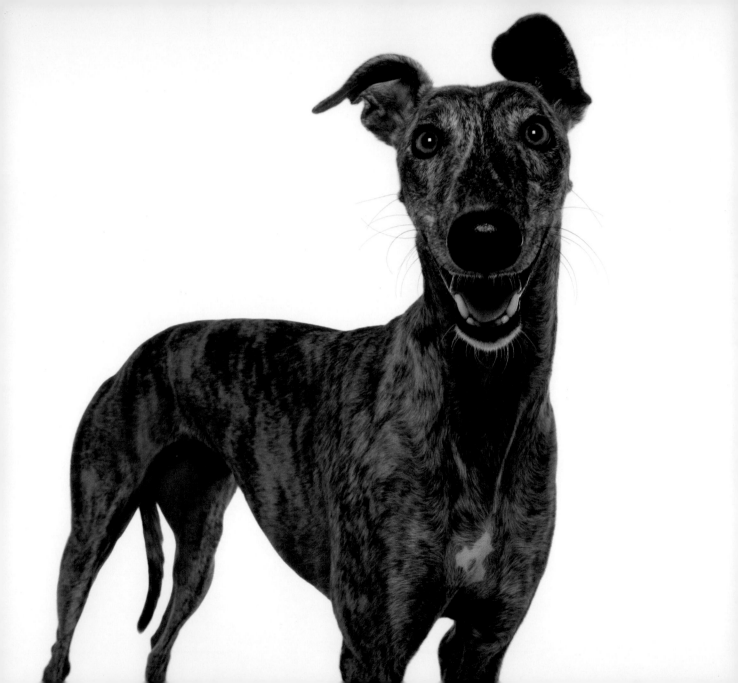

VIOLET

18 months old

Human:
Julie

It had been 18 months since I had to put my beloved Rusty down due to cancer. Two friends, Lorri and Angela, invited me on a greyhound walk and I fell in love with the breed. So, I decided to adopt a greyhound.

Violet has changed my life. I love being at home more, and giving a greyhound a home makes me so happy.

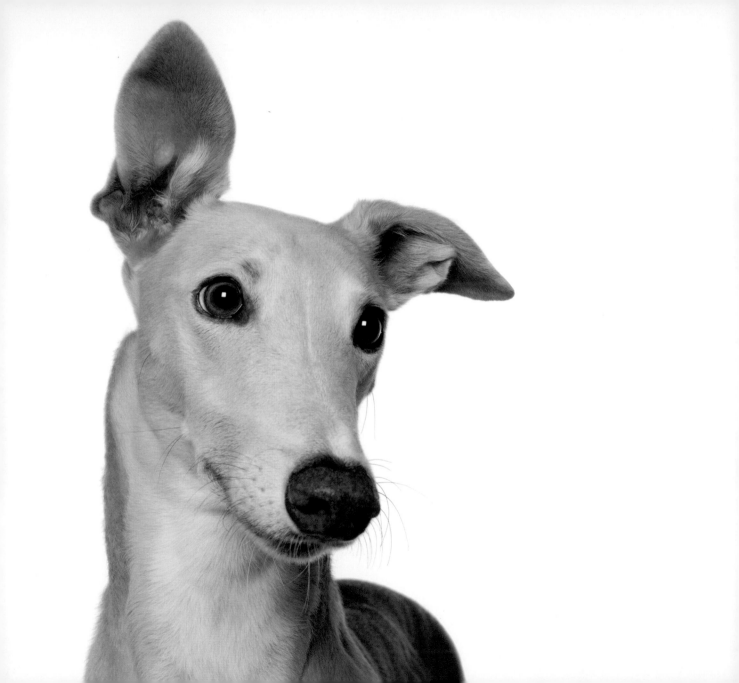

ROSIE

3 years old

**Human:
Amanda**

Wynny, my first greyhound, died after only six weeks, which caused lasting distress for me. I had to find a replacement immediately, for myself and for my bereaved elderly Rhodesian Ridgeback. Rosie had been passed through three foster homes. She had a lot of anxiety issues, but I felt I could help her.

Rosie is a princess in looks. She is an angel to me but a bossy cow to my other dogs. Even though they're all bigger than her, Rosie can make them move with just a look. She does the same with visitors if they stay past dinnertime. Rosie is renowned for her stink eye.

Wynny taught me about an industry I'd been ignorant of, until it killed her so horribly only a few weeks after I got her. Rosie showed me how easy greyhounds are to love and how much gratitude they express every day.

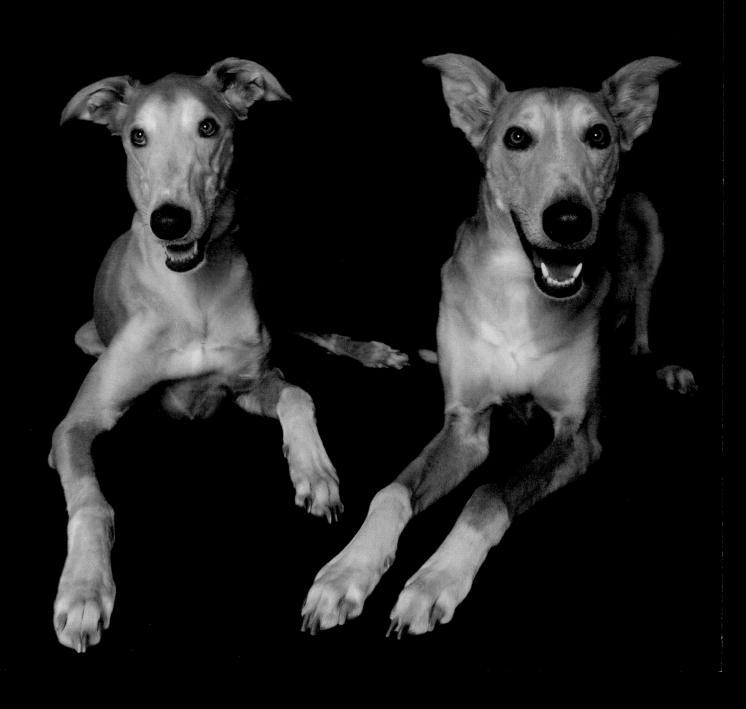

HARLEY & RYDER

**Harley,
12 months old**

**Ryder,
16 months old**

**Human:
Amanda**

I had to have a very special dog put to sleep the week before at only 2 years of age, and Rosie, my greyhound, and I were grieving badly. A rescue group told me about a huge greyhound cross, called Harley, that had just come into foster care. I met him, we fell in love and I adopted him on the spot. A few months after adopting Harley, people started sending me photos of an identical dog in the dogs' refuge home, called Ryder. He had been returned from three adoptive homes and had developed anxiety problems. I took Harley and Rosie to meet Ryder and we all hit it off immediately. So, I adopted him too.

Harley is my 'sunshine boy'. Unfailingly happy with his world, loving every dog and person he meets, and spreading joy wherever he goes, even at the vet. He is famous for standing on his long back legs and giving people a Harley Hug.

Ryder is a far more anxious dog than Harley, who is happiest at home or with people and dogs he already knows. Harley is the brainier brother, and much easier to live with in general.

ELLA

2 years old

**Human:
Debbie**

We very much wanted to adopt a greyhound after we saw a news segment on TV about six or seven years ago. We'd always thought greyhounds were magnificent-looking dogs but, after learning of their life in and then after racing, we were compelled to help and raise awareness in whatever way we could. It was a no-brainer for us.

Greyhounds are awesome dogs. They make exceptional pets. Some slip straight into living the life of a pet with ease; others need more help.

When I asked my family how they would describe Ella's personality, they gave a unanimous reply: 'She's sassy.'

Ella is smart, confident, cheeky, quite the social butterfly and very independent. She's gorgeous and loves nothing more than her daily walks and belly rubs. And Ella makes sure she gets them. She's pretty hard to resist.

Adopting a greyhound has brought us lots of love, joy, laughs, tears and new like-minded hound-loving friends. Ella has spurred us on to continue to support charities that rehabilitate and rehome these beautiful dogs.

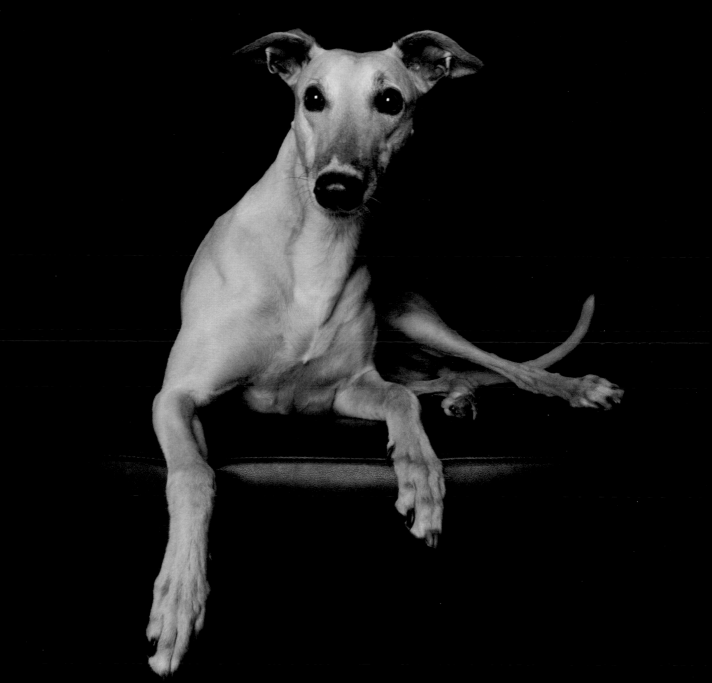

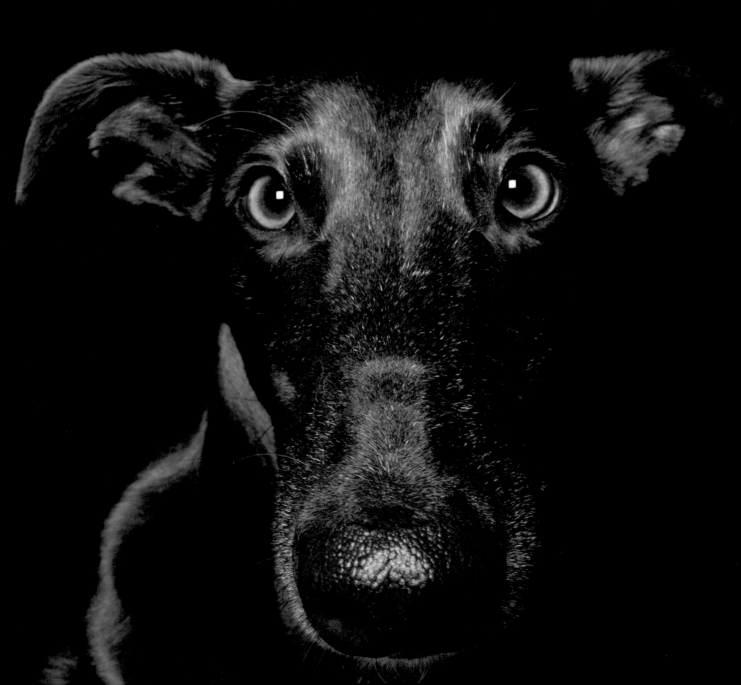

TED

3 years old

Human:
Debbie

When I asked my family to describe Ted's personality, we all agreed. He's 'unique'.

Bless him. He's quirky, a little daft, a bit of a cheeky goofball, lanky and, at times, socially inept. But he's such a love bug. He just loves cuddles and lying on you. He loves to be with you at all times. He's slowly but surely learning manners and social etiquette. Ted is a handsome devil.

LILLY

18 months old

**Human:
Rachel**

Before I adopted Lilly, I had no idea about the plight of greyhounds.
When I found out, I was horrified. A week later, I adopted my first grey.
Lilly has changed my life. One look into her soulful eyes and I was lost.

Lilly is the Queen of Sheba, a poised and regal greyhound. She is also
a one-eyed mummy's girl.

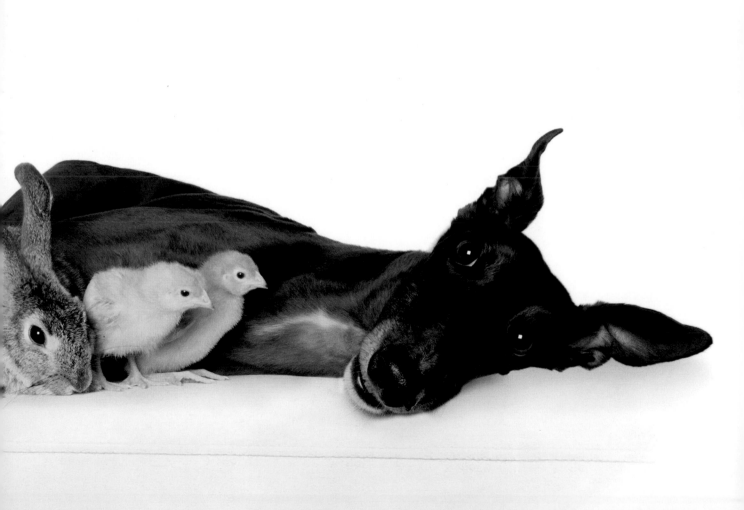

DOTTIE

3 years old

**Human:
Rachel**

I adopted Dottie after we lost our greyhound, Squiggles, and Lilly was not coping being an only dog. Dottie was perfect for Lilly; her personality is attentive and just pure love. She healed us all when she came into our home.

You never forget the passing of one of these incredible hounds, but their love makes your heart big enough for more.

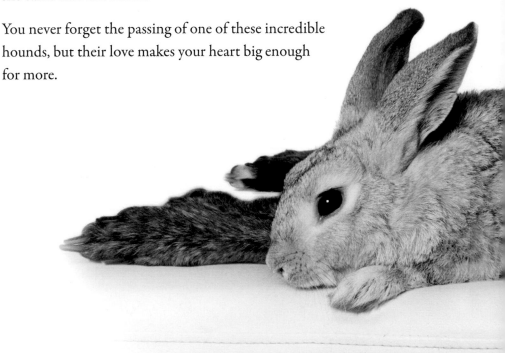

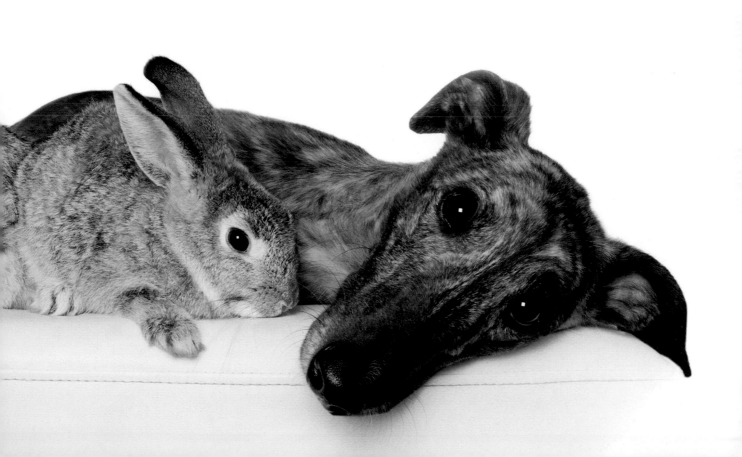

GORDON

4 years old

Humans:
Ariane & James

My father-in-law adopted one first. My initial reaction: but they're so weird, skinny, pointy and funny looking! Then we had to dog-sit him for a month. When he left to go home, I cried and cried. Now, I believe greyhounds are the most beautiful, regal and elegant dogs in the world, with personalities to match.

Gordon is simply a delight. He is perpetually happy and is always thrilled to see you and meet new people. He is somewhat of a local identity around our suburb. People stop to pat Gordon and give him treats, which he graciously accepts. Gordon is loving, sometimes too much so. Despite our initial, perhaps a little half-hearted, protestations, it didn't take him long to cement his place on our bed. Gordon insists on sleeping between us, head on the pillow, with a paw lovingly wrapped around whichever human he prefers that evening.

He is also generous. Gordon will not allow people to enter or exit the house without a gift, usually a shoe selected from his smorgasbord – my husband's shoe rack – or some other item that he deems appropriate. Even throughout his cancer and treatment, he was brave and strong. He rarely complains and does everything he can to make us feel better. We love every day we have with him and could not have asked for a better fur-baby.

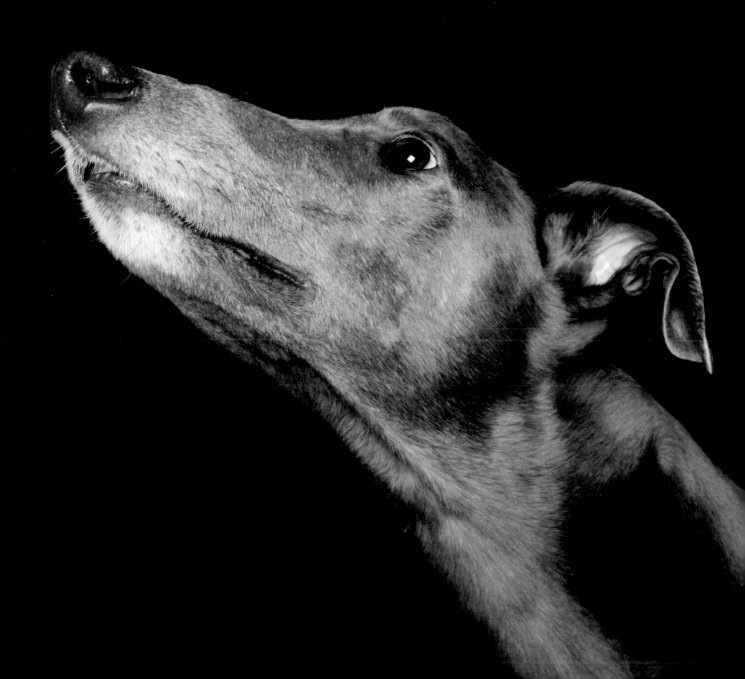

RAY

3 years old

Human:
Lisa

Ray is so tactile; he loves human attention and company. He is gentle, lazy, loving and cheeky. He thinks the spare pillow on my bed is his. If I let him, he would be eyeballing me every morning as I opened my eyes! My two boys are always saying how much they love the dogs more than me. Charming ...

I lost my mum to cancer in 2014. I wanted to do something to make a difference and help me heal, and I ended up fostering for Greyhound Angels. I assisted approximately 12 greyhounds to transition and find new homes. I loved seeing them blossom with confidence and enjoy home life, just being a dog. Then we had a lull in fostering but my family missed having a dog around. So, after working on the family to adopt, we went to see a handsome blue at Kalamunda Market with Greyhound Adoptions. He came home an hour later. Welcome, Ray!

This was in January 2015, and Ray is now 5 years old. It has helped us tremendously, having a focus and something to love. For me, Ray has helped me to enjoy life once again. For my youngest son, Ray is a therapy hound, helping to regulate and calm him when life with autism gets too much.

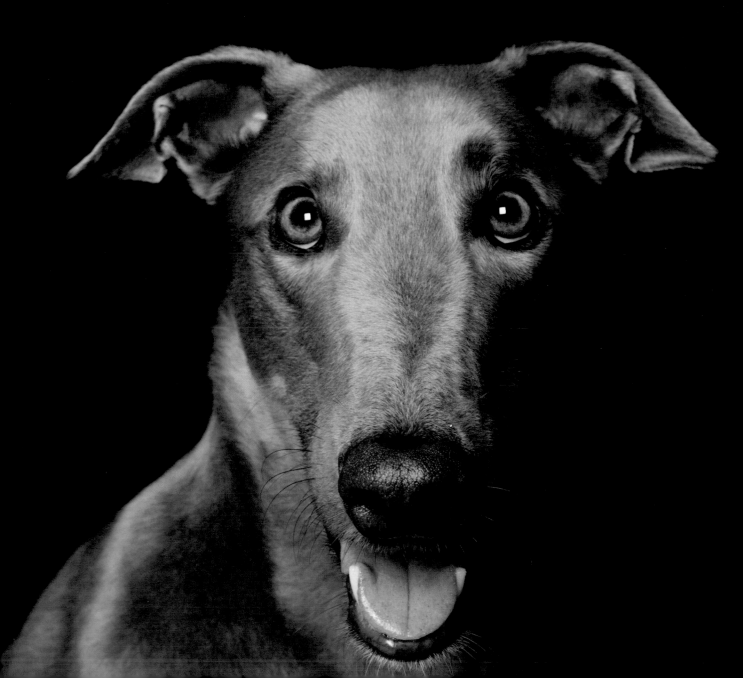

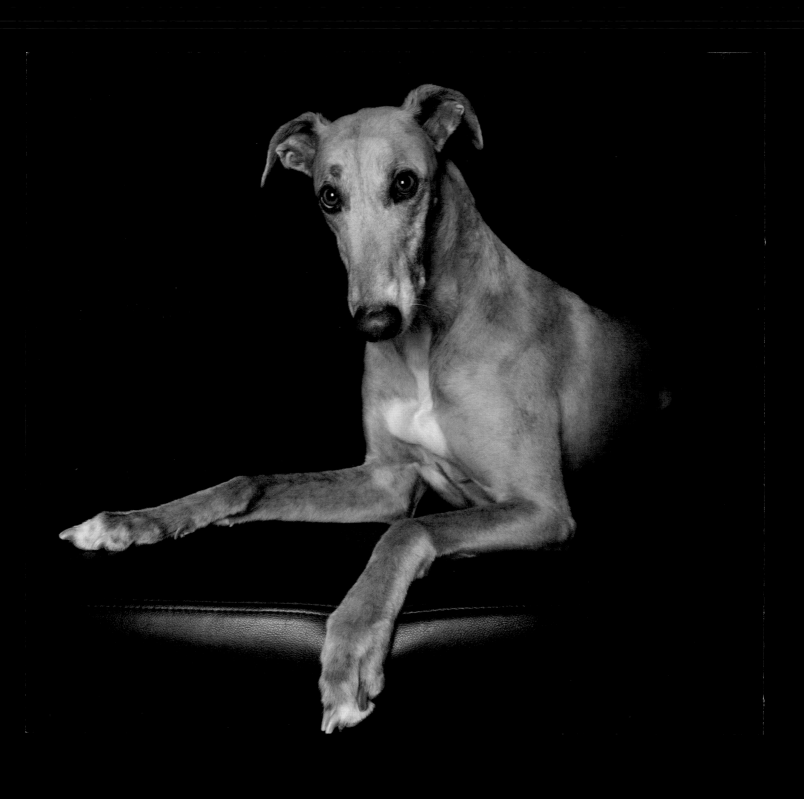

GRETEL

5 years old

Human:
Lisa

After the loss of my mum, I had such a gap in my heart. When I saw Gretel at a GreyhoundAngels fete, I immediately knew she was the one. Gretel came to live with us fairly timid and unsure of herself. Not now! She has the waggiest tail and is the boss of the house, a proper princess wanting all our love and cuddles.

Her race name was Gretel 2 and, apparently, she was quite successful in her day. She soon fitted in with our family and her playful, loyal nature shone. I have never heard her bark. She is tactile but independent, too. Gretel is a joy to have around, keen to please and easy to train. She gets on beautifully with Ray, my other greyhound. Having two greys fits so well; they are ideal for us as they make great family dogs.

Our greys have turned our house into a home. These gentle creatures have so much love to give and have helped me in my journey to accept the loss of my mum and carry on. I feel blessed they came into our lives – it was meant to be. Greyhounds are such a fantastic breed and so overlooked. They have helped my family to thrive and flourish. Keep up the great work Alex and GreyhoundAngels!

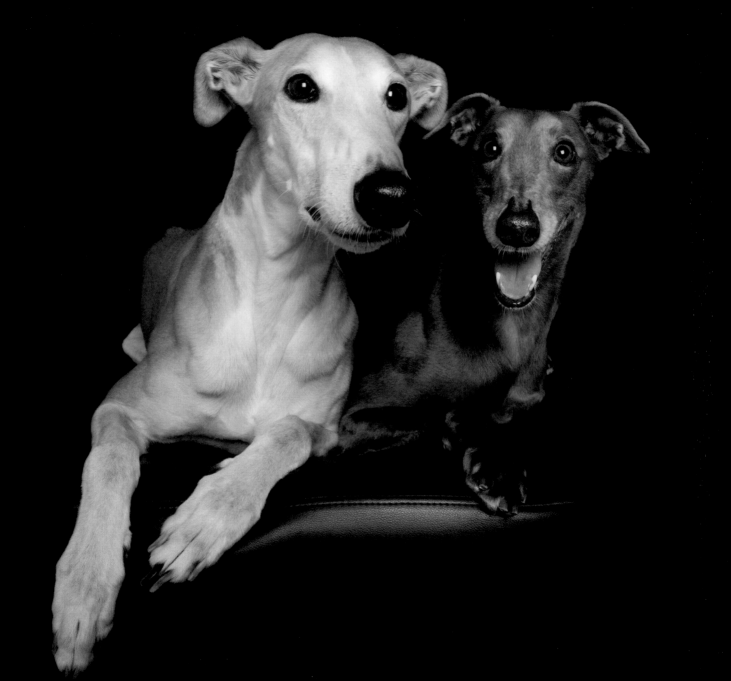

JUNIOR & HANNAH

**Junior,
9 years old**

**Hannah,
4 years old
(nearly 5)**

**Human:
Kate**

I decided to adopt Hannah because I am passionate about animal welfare and as a kid, I always loved Santa's Little Helper on *The Simpsons*. I quickly learnt that greyhounds are so lovable that you can't just have one; I fell in love with Junior and adopted him as well.

Personality-wise, Junior and Hannah could not be more different. Hannah is cheeky and the kind of dog that will steal your spot on the couch, whereas Junior was nurturing and loved cuddles. He was never more than a few steps away from me at any given time.

I never knew how much adopting greyhounds would change my world. It made me more passionate about support animals – Junior was one for me for the four-and-a-half amazing years we had together, before his passing earlier this year. He would stay by my side when I was bed-bound; he was always gentle and we would lean against each other to walk together.

I now have an amazing greyhound named Myrtle in my life. If I had never adopted Hannah in 2012, I would never have known love like these three treasures have given me.

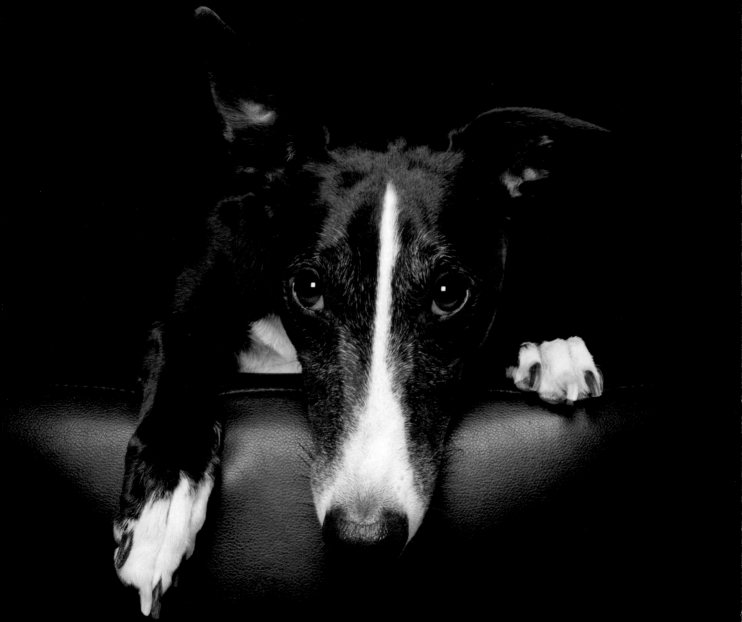

INDI

5 months old

**Humans:
Mel & Tom**

We always said, when we moved into our own home, we would adopt a rescue dog. Having volunteered in animal shelters, it was a no-brainer. We were going to get a Staffy, then we dog-sat for Alex and her partner when they were on holidays. We wanted to keep Pip, their greyhound cross, but figured they would want her back. So three months later, we welcomed 5-month-old Indi into our family. We have never looked back.

Indi was an exuberant puppy and she hasn't grown up. She loves zoomies, ballerina spinning and terrorising her younger brother, Levi (don't worry, he regularly pays her back). Indi loves life and, for her, everything is an adventure.

If she doesn't like something, she lets you know her dissatisfaction immediately. Indi is the master of the stink eye and of the greyhound scream of death. She can also limp for attention. I have been stopped on the street many times and asked if she is normal, to which I answer, 'Of course not, she's Indi!'

Greyhounds are our life now. It's kind of like becoming a member of a cult – but in a good way. Our weekends are full of activities for them. I also give up much of my free time to help with animal welfare and greyhound advocacy causes, but we wouldn't have it any other way. Indi and Levi, our second grey, have enriched our lives so much. We love having them in our family.

LEVI

2 years old

**Humans:
Mel & Tom**

Levi came into our lives because my husband wanted a boy greyhound for gender balance in the house. Levi and Indi are Ying and Yang. Levi is a placid, calm boy for only 2 years old. He is also a great big doofus and a mummy's boy. You will find him either sitting in my lap – all 32 kg – or walking on my right side, touching my thigh. Levi falls off the couch constantly, he huffs if he isn't happy about something and he yells when he is hungry, which is often.

Although, Levi isn't as dumb as we thought. He figured out how to open the fridge one day when we were at work. He ate 1 kg of chocolate custard, 500 g of butter and two spicy chorizo sausages. Needless to say, Levi was very sick. We installed childproof locks soon after.

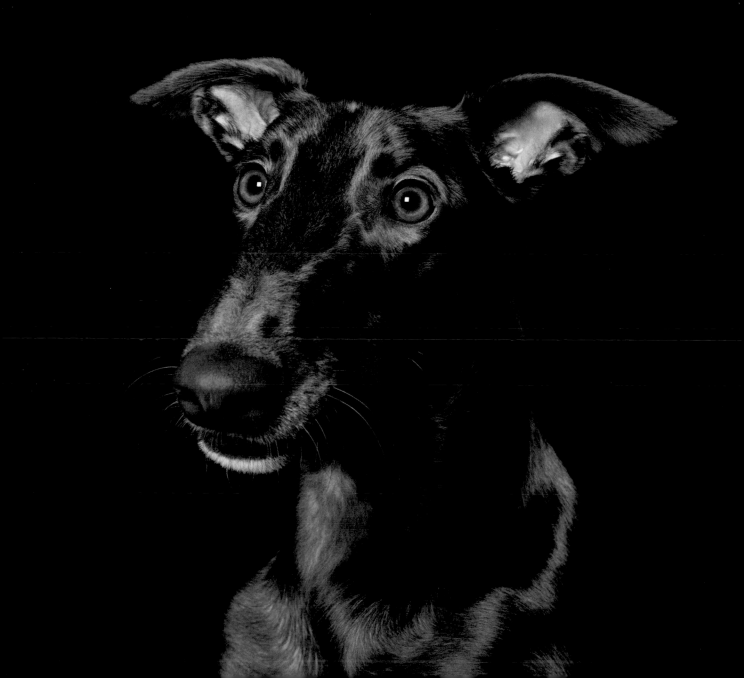

Having had beagles all my life, I wanted another hound breed, but our family was not ready for another puppy, so we decided on an older dog. I had heard such great things about retired racing greyhounds as pets and loved the idea of introducing a dog that had been raised in kennels to the softer side of life.

I can sum up Jagger in two words: adorable goofball. He makes us laugh every single day with his goofiness – whether it's crazy zoomies around the house, lying around with his tongue hanging out and his feet in the air, or dancing for his dinner. He loves all people, especially children, and will flirt with anyone for ear scratches and cuddles.

In so many ways, Jagger has changed our lives for the better. His love is unconditional and knows no bounds. He fills our home with joy and affection and we can't imagine life without him. Once you go grey,

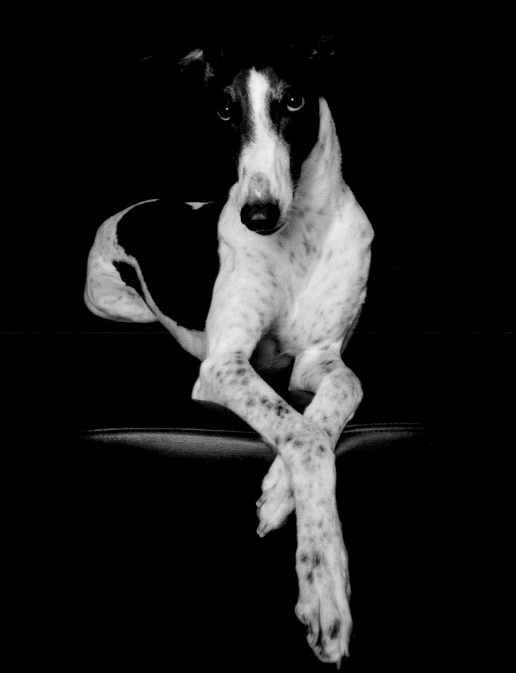

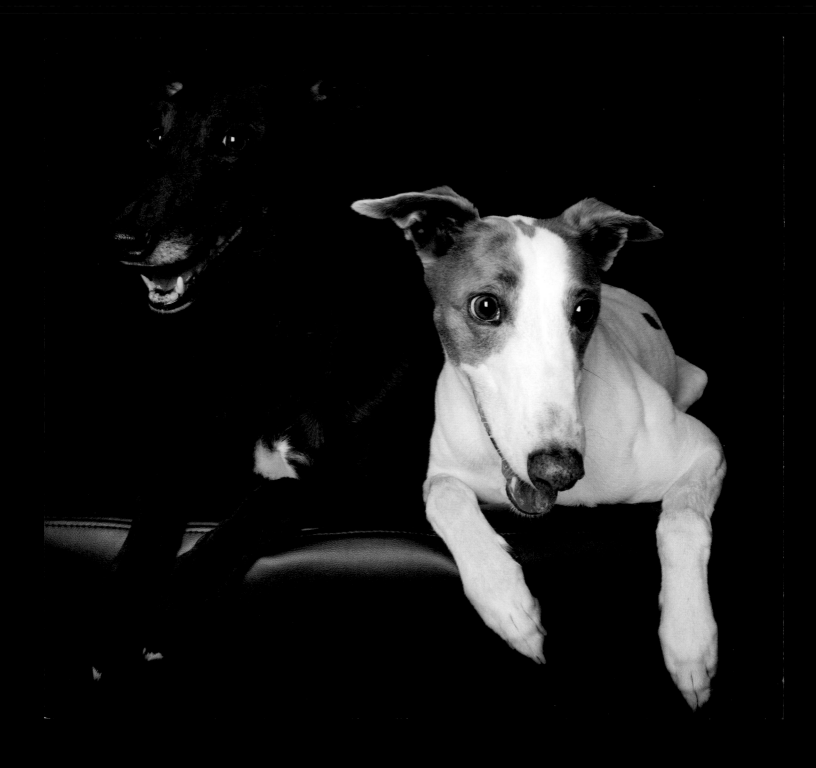

JAX & JESS

Jax,
21 months old

Jess,
6 years old

Human:
Cassie

I was always interested in greyhounds because rescue pages are flooded with greys, but they scared me. I wasn't sure if they would need a stronger pack leader than me, and I thought maybe they would be aggressive. Now, I am their biggest fan.

Jax is a completely different dog from when I first met him. He is sweet, gentle, affectionate, energetic, loving and gets along great with all other animals big and small, including rats, cats and humans. My children's friends, who were scared to death of dogs, will now follow Jax around my house in search of more cuddles.

Jess was my adventurer. She never missed an opportunity to explore and make new friends. Once, she walked right into a stranger's house and lay down on their kitchen floor.

Jess died from bone cancer in 2016. I now have a new grey called Lexie, to keep Jax company when I'm not here.

Greyhounds are just so easy. I'm now extremely anti-racing and would do anything for any greyhound.

JELLYBEAN WITH MONKEY

3 years old

**Human:
Ivana**

When I decided to adopt a grey, my friend Jodie, who volunteers at Shenton Park Dogs' Refuge Home, said there was one that'd been there a while and I should go have a look. Jellybean was the first greyhound I had ever met. And she needed someone who could commit to training her. But I wanted a dog and she needed a home – I just had to convince my husband, Will.

When we went to meet her together, she didn't want anything to do with us. Jellybean went to the furthest corner of the enclosure and fell asleep. Will was confused as to why I wanted this dog that wasn't at all interested in us. I couldn't explain why, I just did.

Jellybean is more like a cat than a dog. She was aloof, stubborn and wilful to begin with; it was almost as if we had to earn her respect before she decided to be obedient. The best part has been watching her change and become more friendly. She now enjoys cuddles, and she has dog and chicken friends.

I am constantly in awe of her beauty, elegance and gentle nature. Our hearts burst with joy when she gets excited and does goofy greyhound things like zoomies and ear flaps that end in her tongue hanging out. I promised Jellybean we would take care of her till she was old, grey and toothless. At 10 years old now, she is still doing great!

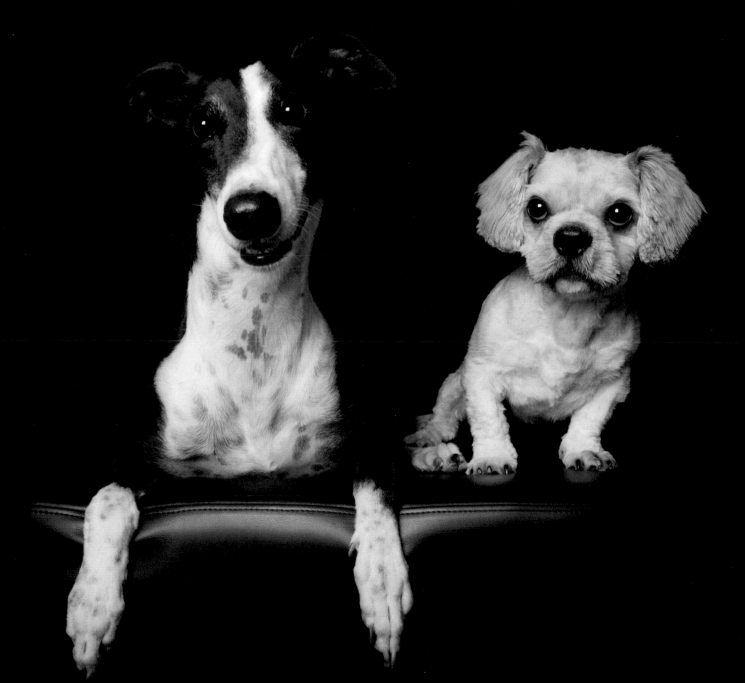

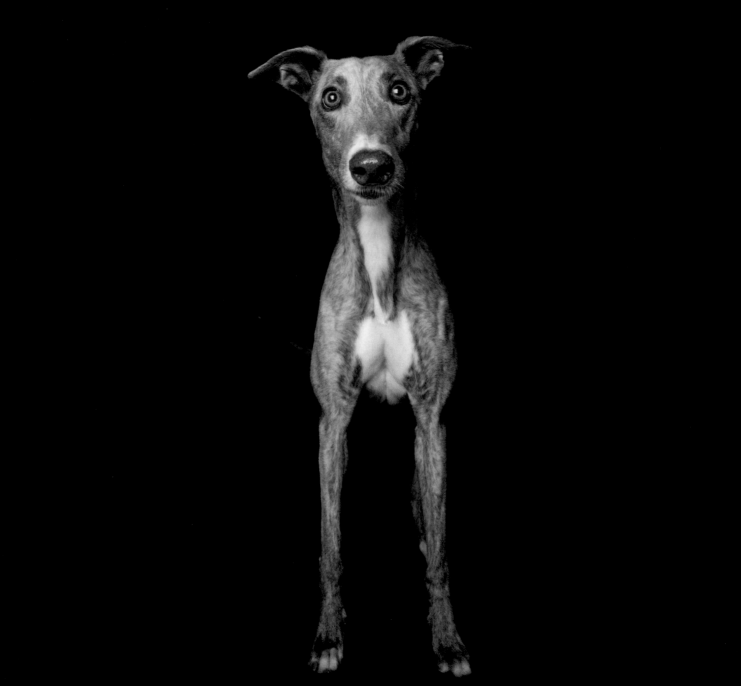

JOJO

3 years old

**Humans:
Aldrin & Poh**

We have always wanted a rescue doggy. We frequented the dogs' refuge but could never find one suitable for our busy, career-oriented lifestyle. Then we came across a fostered greyhound and decided to meet her in person. That first meeting – experiencing up close her gentle nature, elegance and total smoochiness – was nothing short of love at first sight.

Jojo's couch potato tendencies are rivalled only by her love of walkies and mealtimes. One of her trademark moves is to fixate on you with her lovely, big caramel eyes. More often than not, that leads to her getting what she wants, usually a yummy treat.

We have become completely obsessed and have developed a knack for spotting other greyhounds from far away, pointing and stalking until we get close enough to say hello and give them a cuddle. Funnily, other greyhound owners do the same thing!

Jojo has taught us more compassion and empathy than we thought we would ever experience. We love her dearly and we are so glad she has found us.

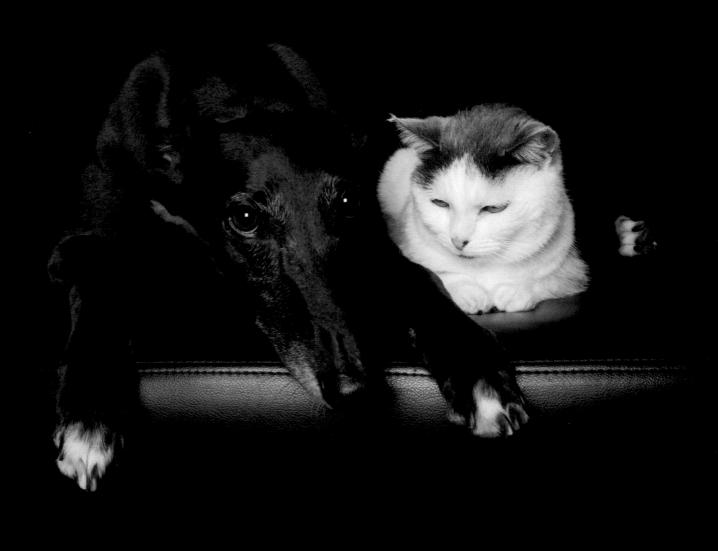

KITTY WITH FLATCAT

2 years old

Human:
Christine

As a vet, so much of our basic training occurs on greyhounds, which are seen as wastage after racing injuries. In my first year of study, I vowed that one day, I would give back to them. Through adoption and being involved in greyhound rescue, hopefully I have.

I adopted Kitty after her trainer presented her for euthanasia because of an extremely minor racing injury. Kitty was every bit as friendly and loving that day, the day that was meant to be her death, as she is today.

Kitty adores people and she is extremely closely bonded to me. Kitty doesn't really care either way about other dogs, but she adores cats. Her favourite things are snuggles in bed with me and the cat, and zoomies in the yard followed by a nap. She also loves strolling along the beach, getting her feet wet. Her favourite TV show is *Gogglebox*, followed by *The Bachelor*.

Adopting a greyhound has given me my best friend. Kitty makes my life richer every day – loving her has added warmth to my life and more meaning to my work. It has also connected me with greyhound rescue and other greyhound owners – some of the most generous, big-hearted, dedicated people I've ever met. Not a moment goes by that I am not grateful to have Kitty in my life.

LEXI

18 months old

Human:
Laura

I started volunteering at Shenton Park Dogs' Refuge Home to get my 'dog fix', as I had to leave behind a border collie in the UK with my parents when I moved to Perth. However, I still kept my eye out for a suitable dog to make our house a home. Then I met Lexi. I went into her kennel to ask her if she wanted a walk, and she play-bowed and wooed me. I knew I'd found the dog for me.

Lexi is such a character. She is one of the most talkative dogs I have ever met. She woos us when she wants a walk, along with stretching her front and back legs. If we are home slightly later than usual from work, we get a woo to tell us off, which is a bit deeper than a walk woo. She even tells off the crows and magpies perched on the phone lines above.

Adopting a greyhound has changed our lives through the friends that we have made. We often go to greyhound events, and everyone is really lovely and accepting of Lexi, even though she is the 'fun police' and likes to tell off other dogs with a bark or two. We have fallen in love with greyhounds – all our future dogs will be greys. They have such great personalities, while also being the laziest dogs in the world!

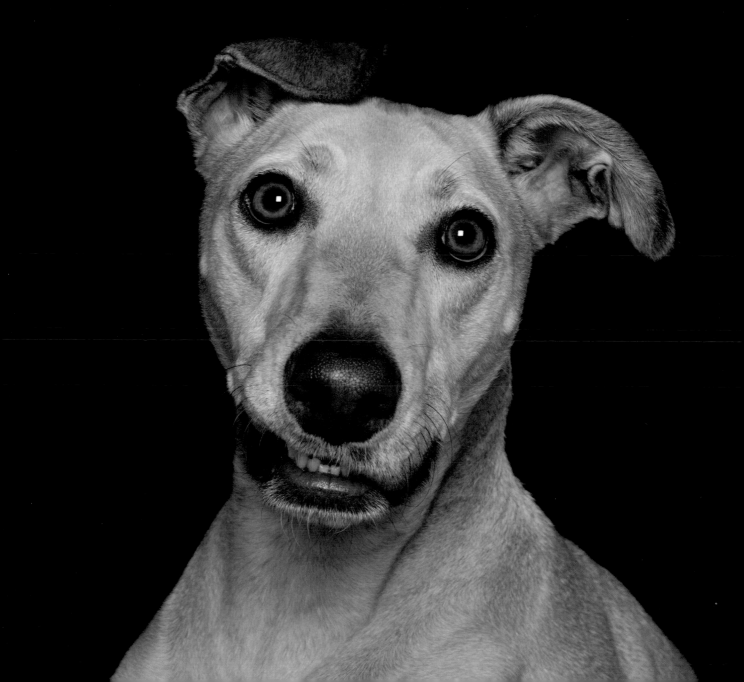

MILES WITH PENELOPE

**3 years,
9 months old**

**Human:
Tammie**

I had never had a dog in my life. My biggest concerns (before) were that dogs slobber, lick, bark, smell, jump on you, shed fur everywhere and need lots of exercise, otherwise they go crazy and destroy things. My good friend Jet introduced me to greyhounds as 'the most cat-like dogs you'll ever meet'. I was smitten when I met her hounds, and it dispelled all my previous worries.

Miles was placid, loving, loyal, gentle and a big dork. He always wanted to cuddle, leaning against me or on my lap. Miles believed in very good dog manners. He let my cat think she ruled the house but, if she became a bit too much, he'd gently put her in her place.

Miles brought a love and comfort to my life that I didn't know existed. Cuddling with a greyhound is the best! It was also the best feeling to see his personality peek out, grow and shine after his retirement from racing. I adored spoiling him and showering him with love. What I gave, he returned ten-fold.

Through the greyhound rescue community, I have met and made friends with some incredible people. I now can't imagine my life without a greyhound. I miss Miles to this day after losing him to osteosarcoma in early 2017, but the time I had with him has changed my world for the better, forever.

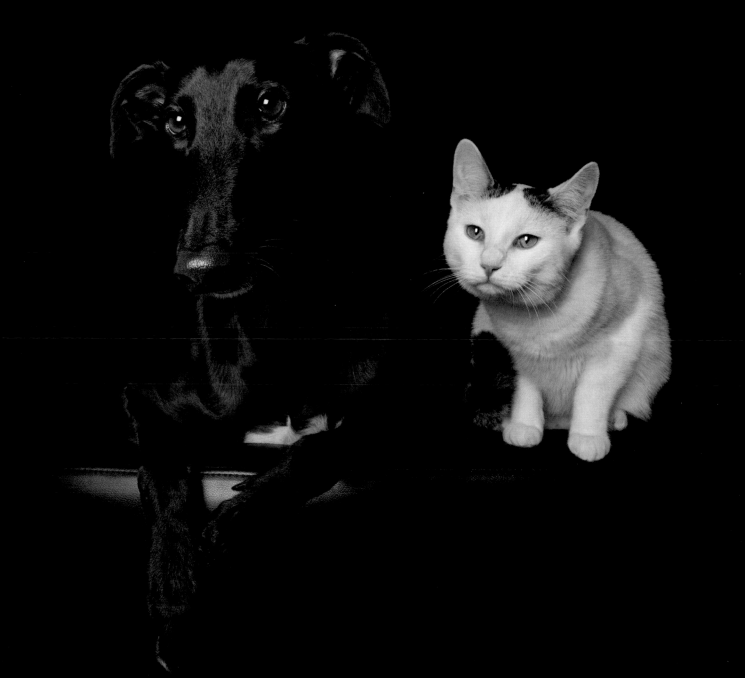

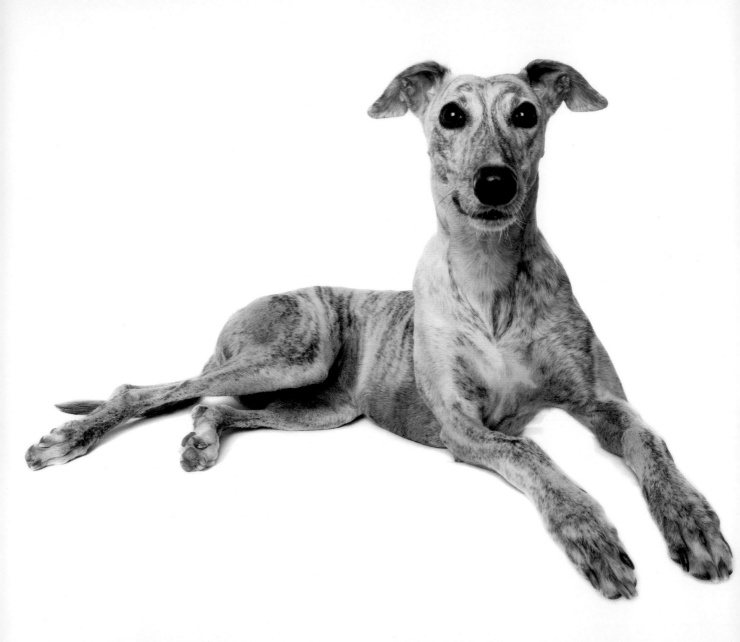

MISTY

4 years old

Humans:
Andrea & Aiden

I have always been a 'cat person'. My husband nagged me for nearly a year to adopt a dog. Little did I know, the biggest greyhound secret of them all is how much like giant cats they really are. When I finally got to meet a greyhound, I was hooked.

Misty is the ultimate greyhound princess – she demands attention and love. She's the perfect ambassadog and spends weekends at events, showing people how wonderful greyhounds are and lapping up all the attention. The most frequent comment I get is how cute she is. Her favourite pastimes include helping her cat sisters and human companions to finish off their meals. Anytime I'm eating, her snoot is right there, waiting expectantly to get her share.

Misty introduced me to the wonderful greyhound owners' community/ cult and led me to get our second greyhound, Leah. I have had the pleasure of their company and love every day for nearly five years, and I want everyone and every greyhound to experience what we have. I don't think anyone will ever be as happy to see me when I get home than Misty and Leah are. I really can't imagine my life without them.

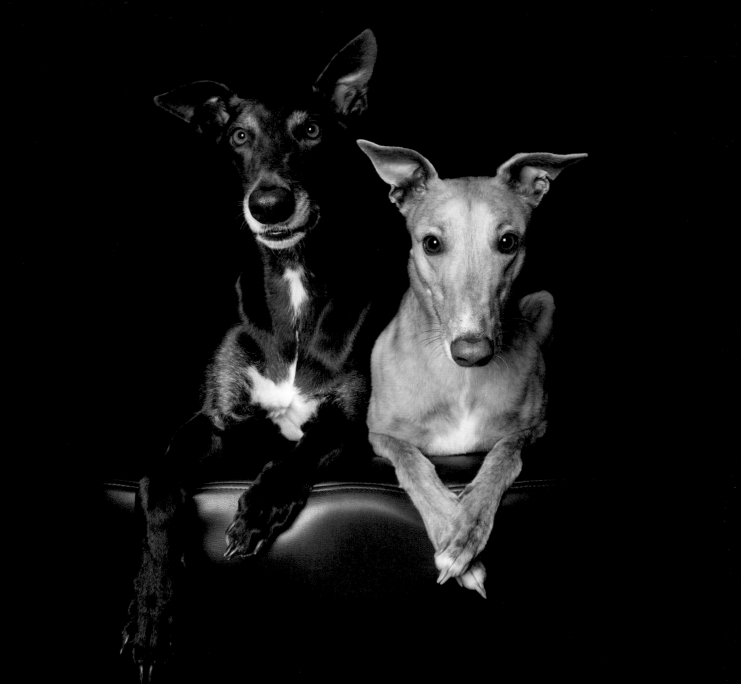

MULLY & FELICITY

**Mully,
3 years old**

**Felicity,
4 years old**

**Humans:
Jordan & Corie**

Corie and I adopted greyhounds because we wanted to give such beautiful animals a second chance. They deserve a new life, to know what it's like not to race but to be a family dog that is loved and cared for, as they should be.

Mully was our first foster fail. When we were told they had a greyhound for us to foster, we had no clue what we were in for. We were informed that he had been adopted twice and given back both times. We took him on board and all he did was sleep, eat and want love! Corie and I fell in love with Mully's grumpy-old-man type personality. At the same time, he was just a baby in our eyes.

Felicity, our most recently adopted brindle girl, is a cheeky young lady. Her personality is so different to our other grey. Felicity was abandoned and left in a pound with only a little jacket. We still can't understand how anyone could leave such a beautiful girl. She is a fun, playful but lazy girl with an elegant side to her.

Adopting greyhounds changed our lives so much, not only by having two dogs, but also by knowing that our oversized couch potatoes have found their forever family. Just like with any dog, you have your ups and downs, but we would never change it for the world.

NEIL

3 ½ years old

**Human:
Caroline**

Neil quickly won everyone over with his goofy, gentle ways. He introduced many people to the idea that greyhounds make great companions and family pets. Neil was a sweet dog that would make us laugh with his goofball antics, spectacular zoomie outbursts and enthusiasm for sleeping in comfort.

He was slightly terrified of our cat, which would ambush the hound when he walked past unsuspectingly. Yet, at the end of each day we would find them on the couch together, with the cat licking Neil's ears, and Neil seemingly torn between ecstasy and fear.

People joked that Neil was a bit slow on the uptake, but he was easy to train and incredibly perceptive about the people around him. He had a sixth sense for detecting when someone would benefit from stroking his soft head and ears, or just having him flopped out, sound asleep, nearby.

Neil's registered name was Harden Up, which was crazily ironic. He was the most precious dog I have ever encountered. He didn't like walking on wet ground or any extremes of weather. Once, he held out going for a wee for more than 20 hours because it was raining outside and, even then, he peed on the patio pavers because the grass was wet. He had an extensive wardrobe of winter coats and would run up to have them put on when it was chilly, and by chilly I mean anything less than 20 degrees. He had custom greyhound coats designed for a Canadian winter to get through the 'cold' inside our Perth house.

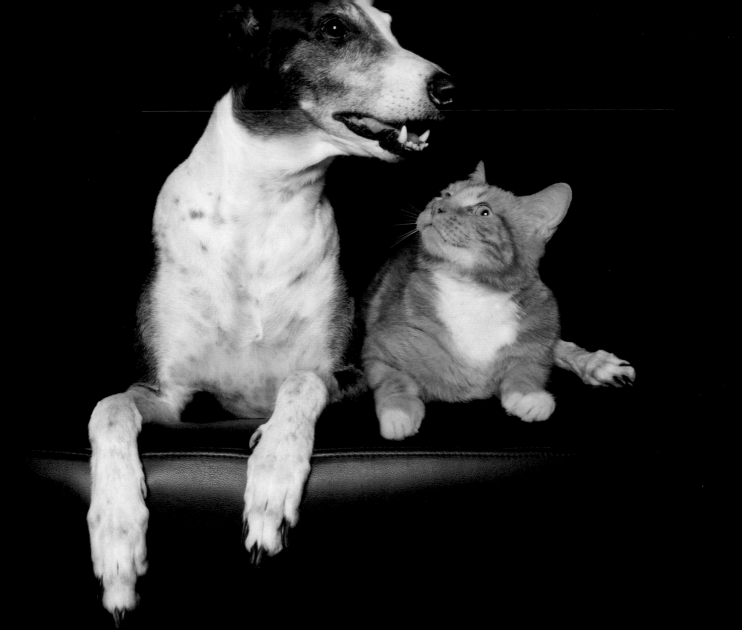

BARNEY WITH NUTSY

2½ years old

**Human:
Kathleen**

I first saw greyhounds at a pet expo and I never forgot their soulful looks and gentle natures. Years later, as soon as I was able to, I adopted two greys. Katie was my first, then six weeks later, Barney. A perfect pair.

Barney had the most gentle nature. He was nervous when he first arrived, but it didn't take long for the goofball in him to emerge. Barney loved riding in the car with me; it didn't matter where I was going or for how long, he wanted to come, head out the window and wind blowing in his face. He was my shadow and he followed me everywhere. Barney never once growled at anyone or any dogs. Even the cat, Nutsy, used to boss him around.

I am very vocal about how great greyhounds are as family dogs and how easy they are to care for. Even now, with both my greys gone, I still adore the breed. I recently walked a greyhound in an awareness walk in Busselton; the lady who owned him couldn't walk too far, so I took him for her. When I can, I will definitely adopt another two greyhounds, or maybe three, who knows?

OSCAR

18 months old

Human:
Vicki

I was looking for another rescue dog to keep my dog at the time company. I thought fostering would be a good option to locate her new best bud. Long story short, my friends all threatened to disown me if I didn't foster fail and adopt Oscar. Not that I needed the peer pressure ;)

Oscar is way more human- than dog-oriented and will beeline for the nearest tradie. I spend a lot of time standing on the outside of groups of people I don't know, while my dog makes new friends.

For about 10 minutes a day, he runs around like a loon, throwing his toys to himself – usually when I first get home from work. The rest of the time, he is comatose. He is a junk-food-seeking missile, able to locate discarded pizza on the side of the road from an impossible distance.

We have a circle of greyhound friends at the local park, who we also meet up with for hound-centric events. I now get a lot more fresh air and sunshine and am a lot more active.

Oscar brings levity when I'm feeling a bit down or distracted – it's hard to be serious when you've just watched a massive, gangly dog walk into a glass door, or can see the cat biting his tail while he's standing there oblivious.

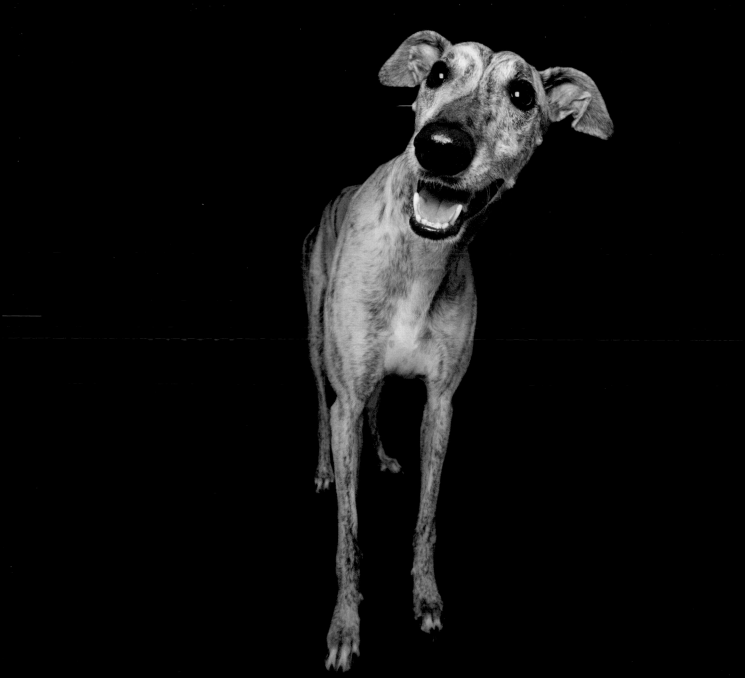

PIXEL AND PIP

13 weeks old

Humans:
Alex & Deb

Emma runs the Brightside Farm Sanctuary in Tasmania. She posted a photo on Facebook of a small black puppy wearing a red coat and, for me, it was love at first sight. I played with Pencil for 4 hours and she started to bond with me. Seeing this, Emma gave her to me as a gift. We renamed her Pixel and she is still the best present I've ever received in my life.

Pixel came to live with us when she was 13 weeks. Her big sister, Pip, a kelpie x greyhound, was so besotted that she stared at her all night, afraid to go asleep in case Pixel wasn't there in the morning. Pixel is love and light. Her life consists of sleeping, doing her tricks of paw and bow, playing bitey face with Pip and saying hi to Macy, her cat sister. She is incredibly smart, has excellent recall off-lead and enjoys tearing up the beach and schnoodling around the park.

It's true that, once you adopt a greyhound, you're hooked. There's something about their big brown eyes, soulful expressions and quirky personalities. They are lazy but funny, cheeky but adorable. And it's nice to give a good home to a dog whose future would otherwise be questionable. Pixel brings us endless laughter and unconditional love. Grey all the way!

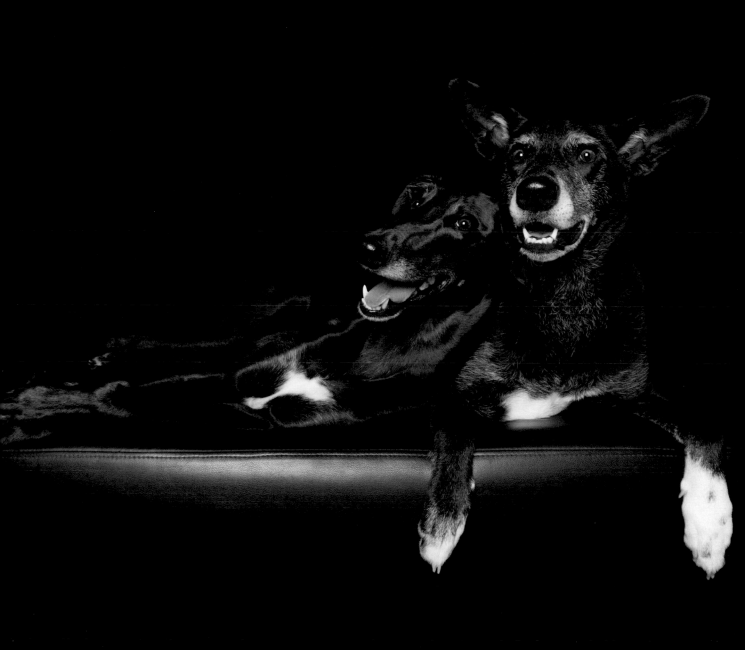

I adopted my first greyhound, Rosie, eight years ago after my university tutor convinced me to do a multimedia assignment on the life of a racing greyhound. I had only just moved out of my family home and didn't have my own dog yet. I grew up with terriers and always wanted to get a Doberman but, after finishing my assignment, I decided that I should adopt a greyhound instead. A few months later, I got Rosie a 'gift' in the form of 16-week-old Jim, my second greyhound and first puppy. Outwardly, Rosie is not impressed by Jim's high spiritedness but, deep down, I know she loves him.

When it comes to personality, Rosie and Jim are polar opposites. Rosie is often given the nickname 'emo Rosie', because she is black and always looks comically miserable during most situations that other dogs would love, for example, going to the beach. In reality, she is not miserable; she is just a quiet, calm, polite, extremely low-maintenance hound.

Rosie is the epitome of the ex-racing greyhound stereotype and everything you would expect after seeing the way this breed is promoted in the public eye. Rosie is happiest when she has spent the day roaching on a couch or bed (upside down with legs akimbo and tongue lolling out), but she still loves to learn during short training sessions.

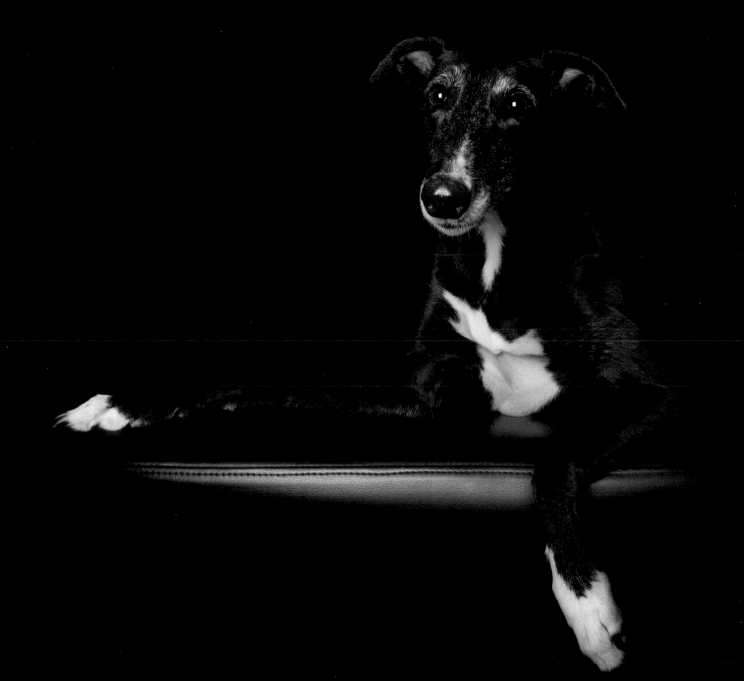

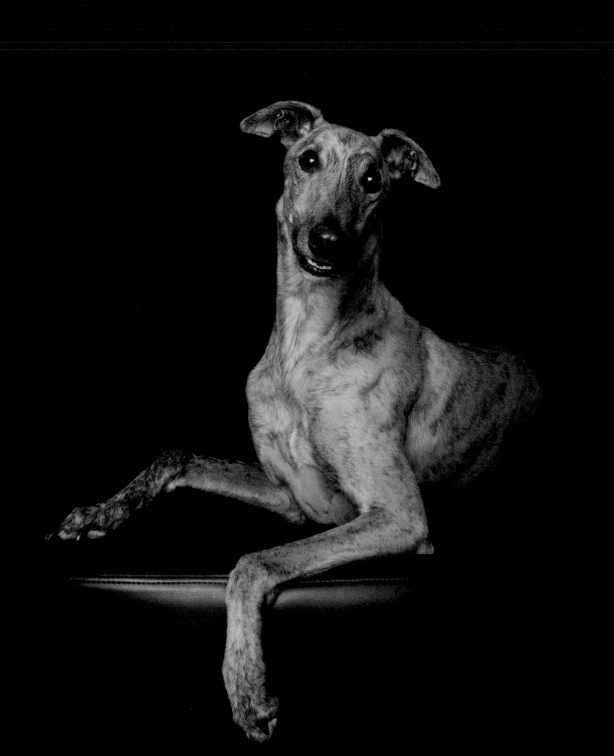

JIM

16 weeks old

**Human:
Vanessa**

Jim was adopted before he became institutionalised and this has resulted in a completely different greyhound, one that does not fit the mould of an ex-racing couch potato. He is a fast learner, bold, energetic, a bit demanding and should have come with a warning label!

Adopting Jim changed my life because we started becoming involved in dog sports. My main aim, once I realised how undervalued greyhounds are when it comes to their intelligence and trainability, was to showcase what they are capable of achieving if given a life outside of racing.

Rosie, my older, ex-racing grey, and Jim have both been shown to their conformation championships and rally obedience novice titles. Jim is the first and only greyhound in Australia to gain Dances with Dogs titles. His favourite activity (surprisingly) is formal obedience, but he has also tried agility, DockDogs and tracking.

Jim loves doing anything to keep active and has also completed a couple of long-distance cross-country style events. I have learned more about training dogs and dog behaviour from my greyhounds than I could have from any other breed.

RUMBA

3 years old

Humans:
Jen & Darren

We were looking for our first dog as a couple, one that would be good for people with allergies and also fit into our lifestyle. After doing some research, greyhounds seemed to match this profile. Ideally, we wanted a rescue dog and came across the charity Give a Greyhound a Home in Scotland. When we first met Rumba, he was malnourished, scarred, bald and a sad soul. He was also soft, gentle, friendly and excited to see us. At that moment, we knew he could be helped and, with the right amount of care, he would make the ideal pet.

Rumba has attitude that he has grown into. He started quiet and withdrawn, but now he is cheeky and welcoming. Rumba communicates with us, snorting when he disapproves of something, stretching when he needs to go out, teeth-rattling when he's happy. He is gentle and calm, we can take him anywhere and he adapts to any situation, taking it all in his stride.

We are now obsessed with greyhounds! Rumba has taught us that, even after everything someone has been through, with the right amount of nurturing, you can recover. He has challenged us to appreciate and enjoy life at a more relaxed pace, and has shown us that it's okay to sit by the river and do nothing for a while, to just enjoy being.

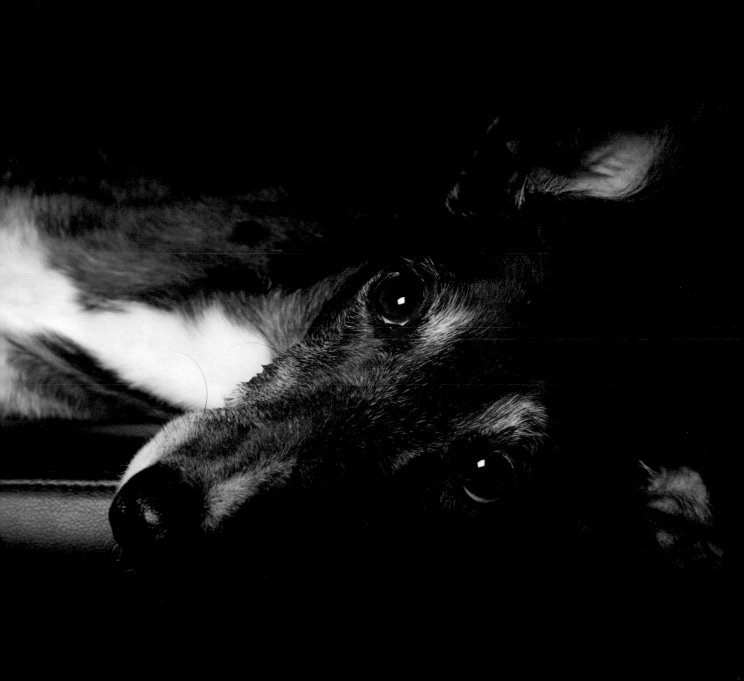

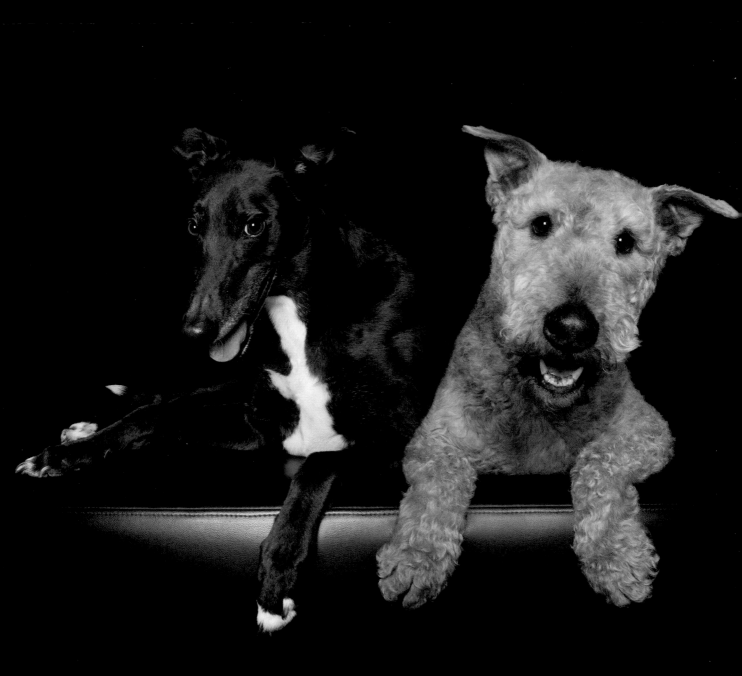

SATCHMO WITH MILLIE

5 years old

**Humans:
Kelly & Steve**

We have fostered more than 20 greyhounds and I cried as each one left us, but I consoled myself with the fact they were moving on to a happy forever home. Then along came Satchmo. He had issues with urinary incontinence. He was with us for two months before going to a very understanding couple. He lived with them for about 12 months, then was returned to our foster care. Satchmo is a beautiful boy, and I was afraid he would continually bounce back to foster care as people struggled to deal with his incontinence. He deserved so much more than that, so he stayed with us.

Satchmo is the easiest dog in the world. He doesn't demand anything. He lives for us returning home from work and going for walks. When we get home, he jumps for joy, so high he has even hit his head on the eaves a few times.

He is super placid, which is not a great surprise for a greyhound. When we recently moved house, our terrier supervised the removalists' every move. Satchmo? He slept in the middle of the lawn, not even bothering to lift his head. But he can run. I continue to be amazed at how fast he can run and how effortless and graceful he makes it seem.

STAN

2 years old

Human:
Emma

Stan's a dude! He's not really a dog, he's a person in a beautiful fur coat, and we have an understanding and a special language of our own. He has his moods, as do we all, sulky in response to a stern look or word, patient with bathing and my attempts at training, joyful in anticipation of a walk. He is a clown with a zest for life when in a playful mood or at the beach, and enthusiastic about most things edible.

He was my seventh foster, and I quickly discovered that I couldn't resist either Stan's good looks or goofy, laid-back personality. Between us, we've fostered more than 40 greyhounds.

Stan's been an advocate for retired racing greyhounds as forever friends, participating in promotional events over the years. He's also supported me through some tough times and has been awesome with helping foster dogs adapt to life beyond the racing kennel. Plus, he's a bit of a celebrity, having graced the sides of buses in Queensland promoting personalised number plates.

My greys have taught me an immense amount about myself, particularly in respect to happiness and patience. They've also helped me to keep fit with daily walks and shovelling sand to rectify their enthusiastic but misplaced attempts at landscaping my garden.

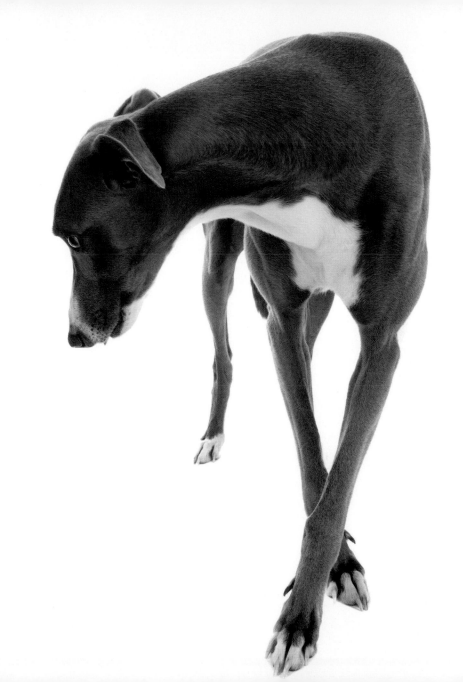

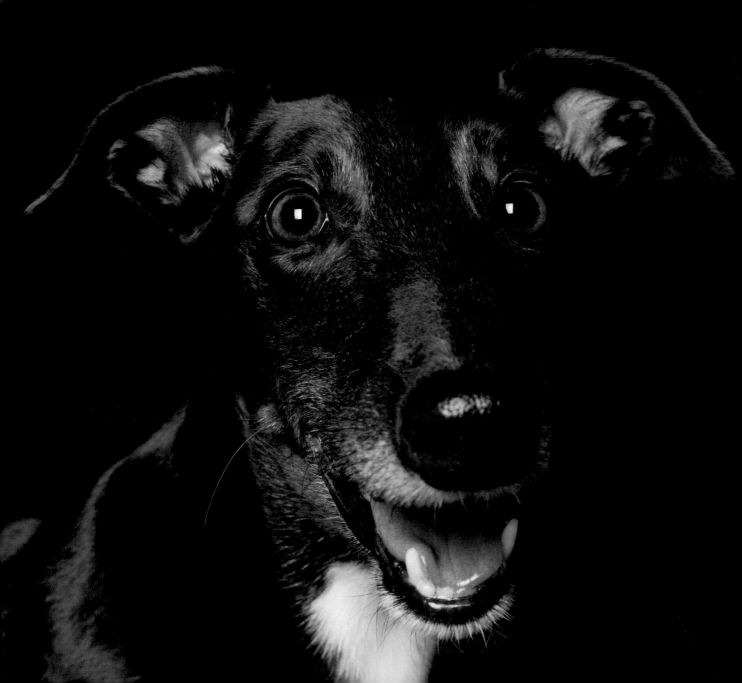

SUZI Q

4 years old

**Human:
Michelle**

Suzi's personality has evolved in her six-plus years with our family. Initially, she was gentle but cautious and submissive. It used to make me quite sad to see that. Over time, she seemed to go through all the stages of development, as though she'd been 'born again'. There was a naughty puppy stage, the rebellious teen, and then she settled down into her current role as quirky, stubborn and increasingly bossy Queen of the Household.

She talks a lot. Suzi demands her treat after dinner, comes and 'roo roos' at me to tell her sister off if she's on the lounge (so Suzi can promptly replace her) and insists on saying hello with her waggy tail to everyone on two or four legs that we encounter on our walks.

Like all greyhounds, she spends much of her life resting, although at 10½, it has become obvious she's slowing down a bit. Still, she bounces around like a joyful kangaroo when it's time for a walk or a drive in the car.

These dogs have changed me into a person who now buys bedding in print fabrics so as not to show the dog hair. I cover my lounge with a throw for their comfort and pretend I don't see dogs upside down on it. I've also taken to buying dog accessories and colourful winter coats, and am happy to play the role of faithful servant.

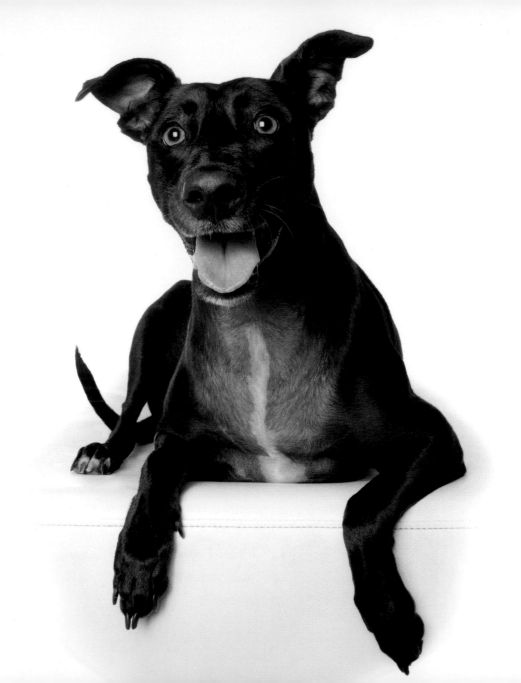

KIRA

(Grey cross)

12 months old

**Human:
Michelle**

Kira is a nervous dog and we had to do some work with her to build her confidence. She's still anxious, but she thrives around family and in situations where she feels secure.

She was very thin when we got her and looked much the grey. By around 3 or 4 years of age, however, Kira started to expand and she kept on growing wider and stockier.

Out of curiosity, I had a DNA test to see what the other 50 per cent of her genetic makeup was. It turns out she's got Staffy blood in her, which possibly explains some of her growth and mannerisms. Though she'll bark like crazy if you knock on our door, she's a gentle soul that does her best to please. Kira doesn't appear to realise how large she has grown and is often found crawling onto my adult son's lap.

TEDDY

4 years old

**Human:
Julie**

We wanted to give a greyhound a loving, happy home where he could experience the joy of cuddles and snuggles and sleeping all day with a smile on his face. We wanted our dog to be free to express himself, which we learned includes digging up the newly seeded lawn, taking up most of our king-size bed and becoming my personal food taster.

We met Teddy with his foster carer, Alyx, on a Saturday afternoon in Kings Park. He came straight over for a cuddle, all waggy tail, and leant against us as only a greyhound can. Teddy is such a sweet and gentle boy.

Teddy loves: riding in the car; his big brother, Ludo the Rottweiler; sleeping in the sun, on the sofa, on our bed; all food – cat food, dog food, my dinner, his dinner, your dinner; chasing a ball but not bringing it back; squeaky toys, especially when I'm on the phone; endless cuddles; walks followed by treats; his teddy bear; his jumper; snuggling on the sofa to watch TV; and giving you a morning kiss.

He gives me a reason to get up each day – who could resist those big, brown eyes and that cold, wet, long nose? He makes me laugh and brings a smile to so many strangers, many of whom ask if they can pat him. He is a special dog; I feel very lucky. I love him to bits.

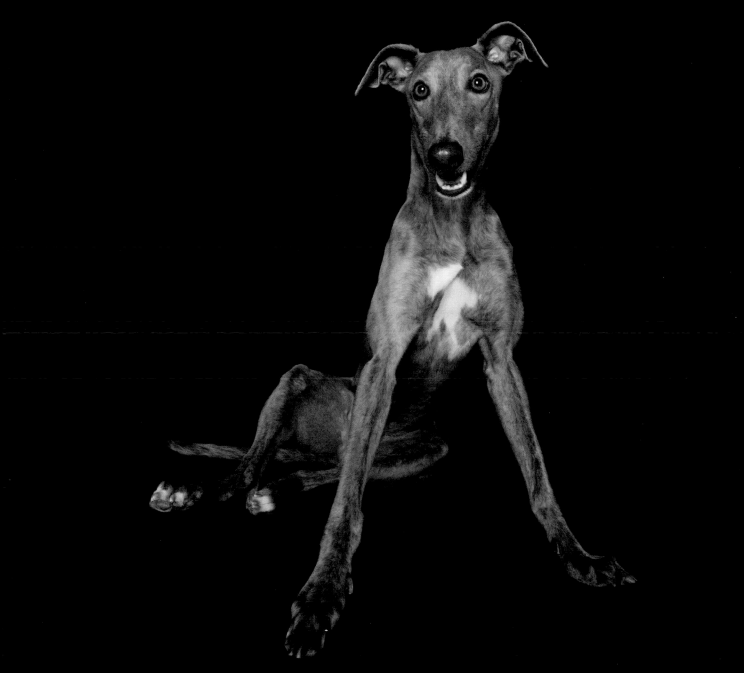

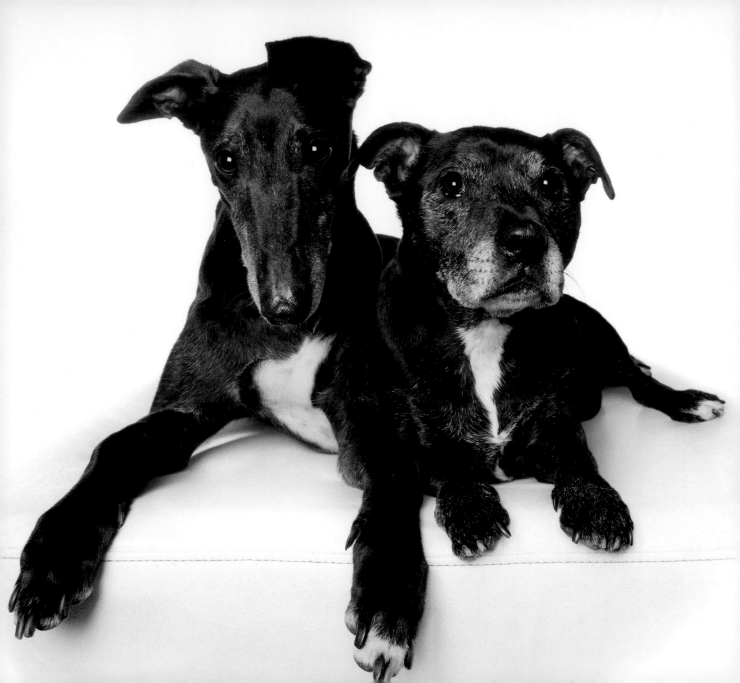

SAM WITH BELLA

6 years old

**Humans:
Rachel & Dave**

We adopted a grey because we knew excessive numbers of them needed to be rescued, but also because they are kind, loyal and gentle souls, and because we're lazy, so they suit our lifestyle.

Sam is an old man but a puppy at heart. He's gentle, loyal, loving and king of the couch. When he's not roaching on the furniture, he's doing zoomies in the backyard and digging up the garden.

Owning a grey means you have a best friend and beautiful companion with you all the time. It has also brought some amazing people into our lives. Being part of the greyhound cult means there are always friends close and a social life to be had. And it's given us the opportunity to educate other people on how wonderful greyhounds are.

LORELEI & WINSTON WITH STANLEY

**Lorelei,
4 years old**

**Winston,
5 years old**

**Human:
Kelly**

We adopted a grey because I had just lost my little dog and I felt there was a dog out there that needed the special kind of TLC that's hard to find. I have a retired racehorse and I wanted to help a retired race dog. No one wanted Lorelie. So I met her, and we had an instant connection. She chose me. She was scared of all people. But she came and lay next to me.

Lori is still scared of people at 5 years old. But when we have our time together, she is a crazy, funny, silly puppy. She has a huge heart and deserved a new life.

Winston came to us because I just had a feeling there was another grey for me. I saw his face on a post from GAP (Greyhound Adoption Program) and asked if I could have him. Initially, they said no as he was very high needs with bad anxiety issues. This just made me want him more. Weeks later, they called and asked if I wanted to meet him. Yes! Lorelei and our cavvy, Stanley, fell in love with him, and so did my kids.

I adore Winston. He is a funny goof that talks and cuddles a lot. Seeing both Lorelei and Winston grow, forgive and heal has taught me to let go of my own life baggage, and that life can change and be amazing if you want it to be. They are proof that anything is possible.

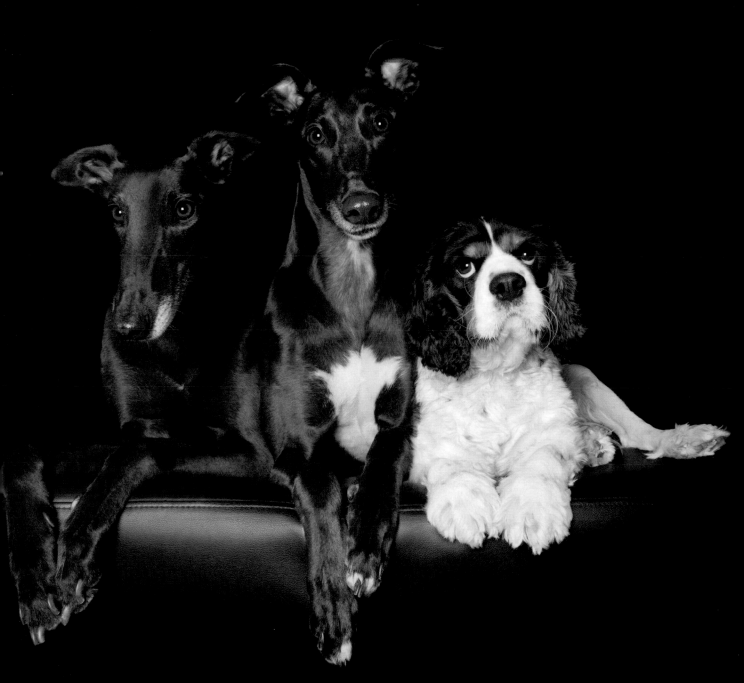

SILAS WITH ZARI

18 months old

Human: Danielle

When I lost my Doberman at a very young age, my Jack Russell was lost without a friend. Only days after his passing, I saw Silas on PetRescue. He looked perfect, but he was in another state and was it too soon? I told myself that, if he was still there in four weeks, it was meant to be. And low and behold, he was.

Silas is the quiet achiever of the family. He does his things and is never a bother. He is very willing to please and will do extraordinary things for me. When I first got Silas – I was his fourth home – he was scared of all new people and especially men. However, after two short years, Silas was wowing the crowds of the Royal Show, showing everyone that greyhounds are great at more things than just racing.

Silas is an extraordinary dog. Not only is he the first greyhound in Australia to earn agility, obedience and endurance titles, but he has also saved the lives of more than a dozen dogs as my vet clinic's blood donor. Silas has shown me it doesn't matter how you start out in life, you can still achieve great things. He is an inspiration to me and to many people and dogs in the greyhound world.

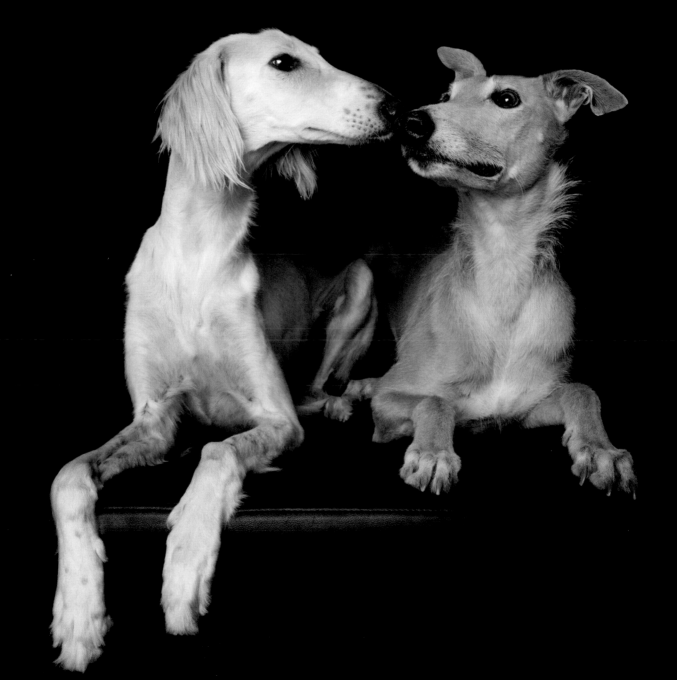

MONTY WITH TUI

4 years old

Human:
Sam

I met my first greyhound at an adoption day and I instantly fell in love. I took home a pamphlet with some information on greyhounds and the racing industry and knew I had to help. About two months later, we adopted Monty.

Monty is your typical greyhound: he loves roaching on the couch, doing zoomies around the house and backyard, and scaring us with the greyhound scream of death. He was a bit quiet when we first adopted him but has come out of his shell so much, with the help of his little sister, Tui. Monty makes me laugh every day with all the silly things he does.

My life has changed so much since adopting Monty. It was the best thing I ever did. With Monty's help, I now do a lot to raise awareness about the racing industry and how many hounds are not so lucky to make it

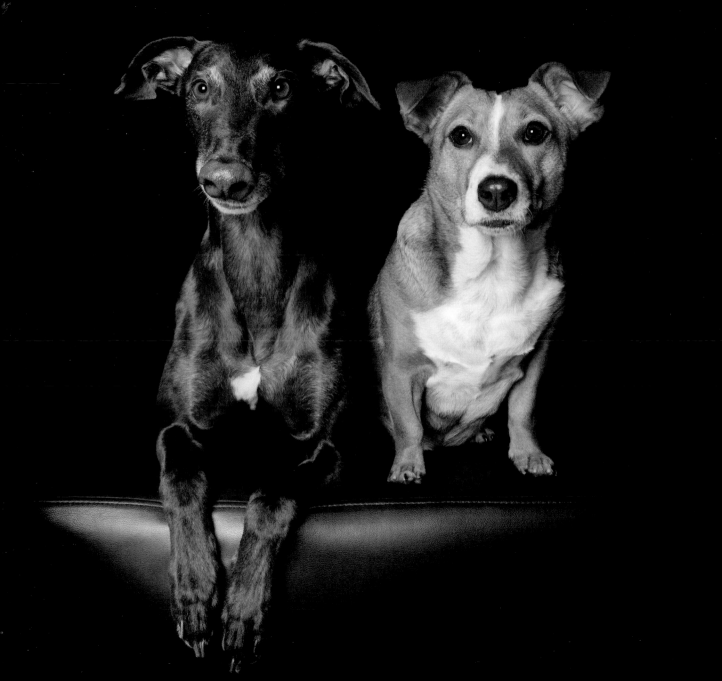

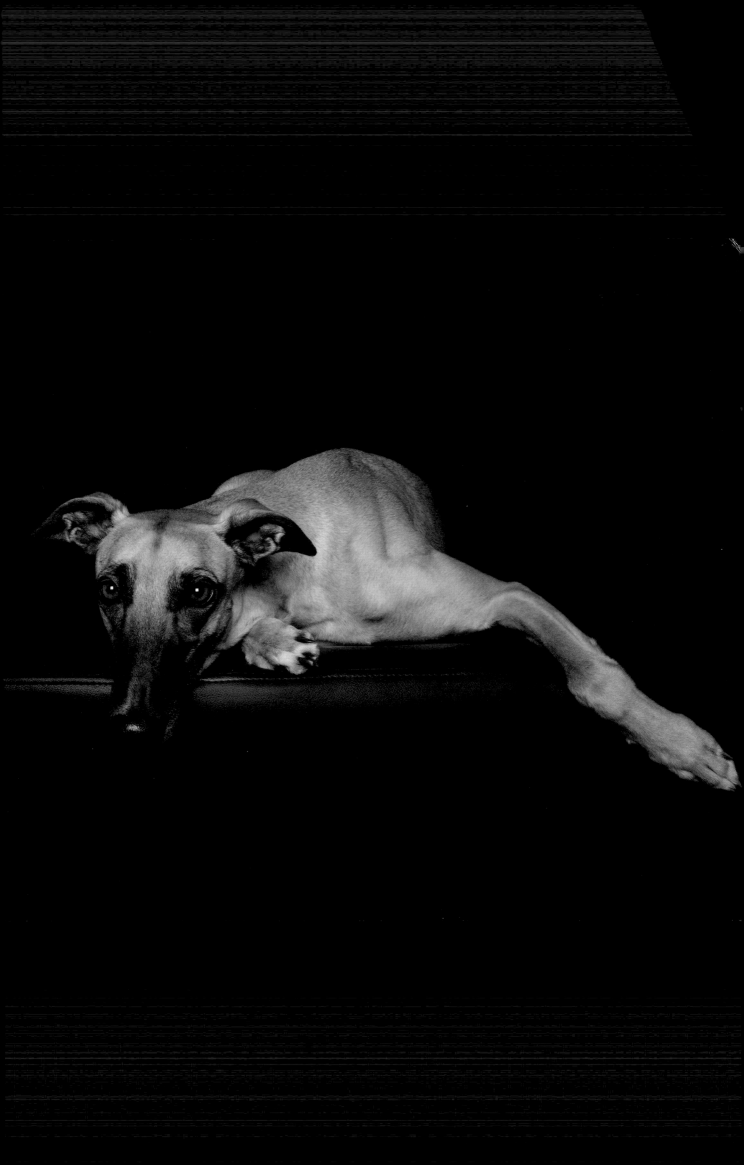

HOLLY

3 years old

**Humans:
Donna & Simon**

Simon spent time with retired greyhounds in England when he was a teenager and he loved their temperament: relaxed and easy going. So, when I was looking for a dog to hang with me in my shop, Simon introduced me to greyhounds at the Subiaco Farmers' Market. I loved their quietness and leaning, I wanted a dog to lean on me – it's very comforting.

Holly is a content dog. She loves going for drives with her homies and listening to rap with the windows down, just as much as she loves chasing swallows in the park. Holly is wary of strangers but, once she gets to know you, she wags her tail and bounds to greet you, and then you'll have to fight her for the couch. She's a different dog from the one we met nearly 12 months ago – completely relaxed and happy in her environment, unless you try to move her from said couch.

Holly makes us so happy. Neither of us had our own dog before, so we hadn't experienced the joy of living with a greyhound. We love watching her run along the beach and at the park, and getting her paws stuck in our face when she roaches in between us on the couch (on her back like a cockroach, all legs in the air).

LARRY

3 years old

**Human:
Albert**

I adopted a greyhound because so many of them are killed after their racing careers are terminated, or because they are deemed too slow or fail to have a chase instinct. Saving a life was my primary consideration.

Larry is a 'person dog'; he likes people. On his walks, Larry always goes towards people we come across, whether they are young or old or big or small, he wags his tail and heads over to them for pats. He loves home comforts and sleeps on the couch during the day and on my bed at night. Larry is calm and patiently waits to be fed.

Yes, adopting a greyhound has changed my life. He is carefree, worry-free and a calming influence on me. Larry has taught me patience and the art of relaxation.

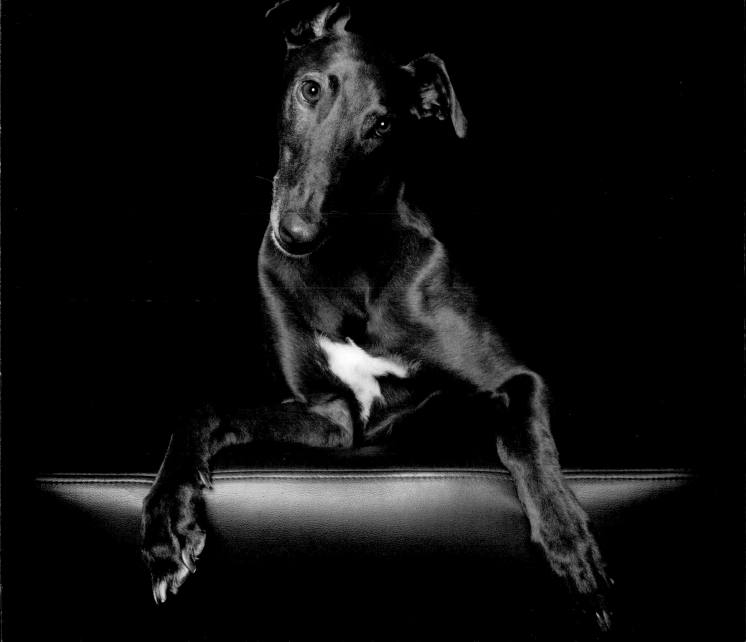

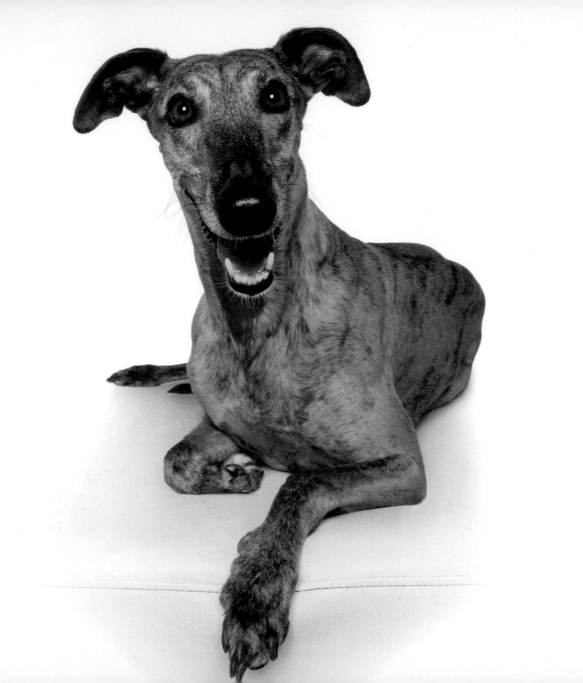

SIENNA

4 years old

Human:
Andrea

It all started at the Royal Show some 20 odd years ago when I saw a GAP (Greyhound Adoption Program) stand. Like most people, I thought that to have a greyhound you'd need a huge amount of room and they'd need tons of exercise, so I was surprised to learn that the opposite was true. I did some research and started really wanting to adopt an ex-racing greyhound. Unfortunately, life often has other plans. It only eventuated a few years ago, but I'm so glad it did.

Sienna is definitely a princess. Or lady. She is fussy when it comes to her food and treats; anything below a five-star à la carte menu just isn't acceptable. She will not poop in the backyard, come rain, hail or shine she has to go walkies. She gets most embarrassed when she farts – can you believe that! And I sometimes get the feeling that she's an outright snob. But, and it's a big but, she is just the most loving girl in the world. Yes, I am biased, but it's true. She also seems to have an innate understanding that my arthritis limits my physical capabilities and has adjusted to that.

I have met some amazing new people and made new friends because of Sienna, and that's the second-best part. The first is just to have her in my life, that certain serenity she brings. The quiet love that I see in her eyes.

PINK

(Grey cross)

7 months old

**Human:
Sam**

We had a rescue greyhound x German shepherd that, despite his past abuse, was the most beautifully natured dog. He made us fall in love with greyhounds. I first saw Miss Pink in a photo sent by a friend, who volunteers at a rescue shelter. It showed the sweetest little face smiling through the kennel door.

Pink is pure joy and happiness – she loves everyone and everything! In 2017, she sat a therapy dog assessment to see if she could visit people in nursing homes and hospitals. She passed with flying colours. As part of the test, when the assessor shouted, 'Bad dog! Go away!', Pink put on her biggest smile and strutted over as if to say, 'Oh, but you haven't met me.'

The staff and residents at the nursing home she visits adore her, and Pink lights up as soon as we pull into the car park. She wiggles with delight as she walks down the corridors. She makes sure to check every door, in case there's someone inside who would like a visit.

Adopting Pink has changed everything. We have a lot of wonderful friends in our lives, thanks to her, and together we are helping to make other people's lives a bit brighter. Pink has shaped how I live my life – to try to see the good in the world, live in the moment and stop sweating the small stuff.

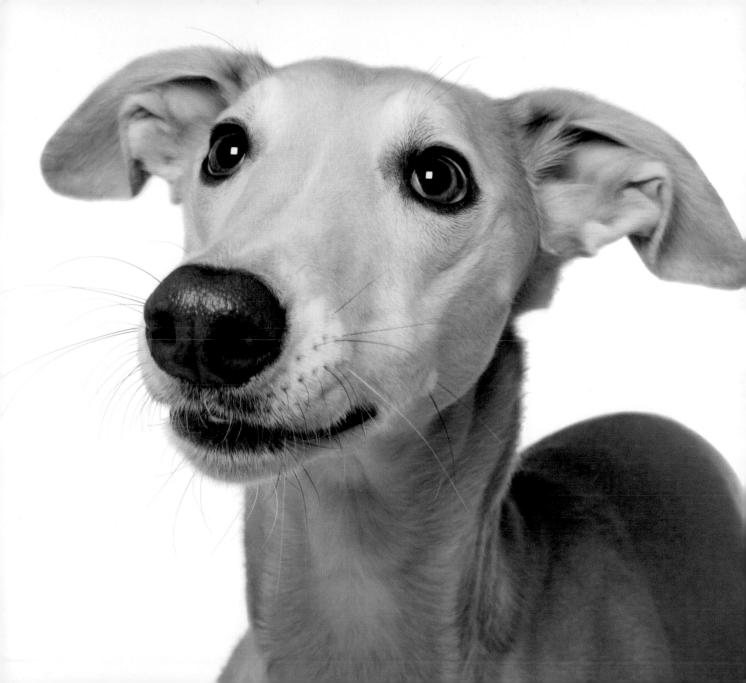

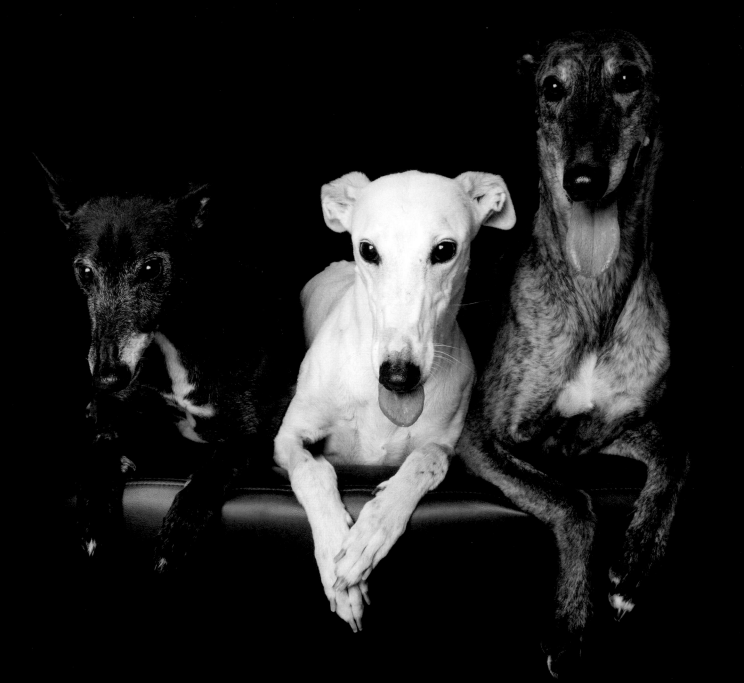

JOHN, ALYSSA & JEFFREY

John,
12 years old

Alyssa,
3 years old

Jeffrey,
4 years old

Human:
Melita

It has been more than two decades since I founded GreyhoundAngels. It's been a long, emotional rollercoaster and, more often than not, it has left me feeling distressed, helpless and defeated. I wouldn't jump at the chance to do it all again but, if there were no other options, I still would. These beautiful dogs are worth it.

John loved his life, despite being physically and mentally disabled and weighing only 22 kg when fully grown. He was a happy, cheeky, quirky, playful, gentle boy, and he had many experiences and adventures, as any dog should. He was, and still is, my longest living greyhound in 23 years.

Alyssa was rescued from a vet clinic by another group. Oh boy, what a firecracker she was on arrival! I'll always be impressed with her and with our journey together. I knew her zest would last well into her older years. I was right. She's turning 14 soon, and it's only in recent months that I have noticed her acting more senior.

Jeffrey was a big, gorgeous, brindle male, quirky and funny. He was always focused on getting to the hydrobath. This involved super speedy legs almost dislocating my forearm, abruptly stopping for an excitable pee, then jumping into the bath, which no other hound would dream of doing.

TIGGER

4 months old

Human:
Caroline

I have always felt the right dog comes to you at the right time. One day, out of the blue, my husband called me and said GAP (Greyhound Adoption Program) had a 4-month-old greyhound puppy. Puppies don't often become available, but Tigger had a slight heart murmur. His trainers decided to adopt him out rather than race him. The moment Tigger came home with us to foster, we looked at his gorgeous face and crazy ears and knew he would be our forever hound.

That tiny puppy has grown into a tall, 40-kg boy. He melts the hearts of everyone he meets. But greyhounds don't just take over your heart; they take over your home, too. No bed or couch is sacrosanct. They sleep for around 20 hours a day, and we often find Tigger in the middle of a bed on his back, legs straight up the air, mouth open and tongue hanging out. When he isn't sleeping, he likes to stay by your side, literally. But don't ever get cross with him and yell, or he will sulk for hours.

You don't really 'adopt' a greyhound. Once you invite one into your home, they envelop you in love and are the most delightful, kind-hearted couch potatoes. You just need to shower them with affection, treats and the occasional soft toy. I truly understand why so many people can't stop at just one.

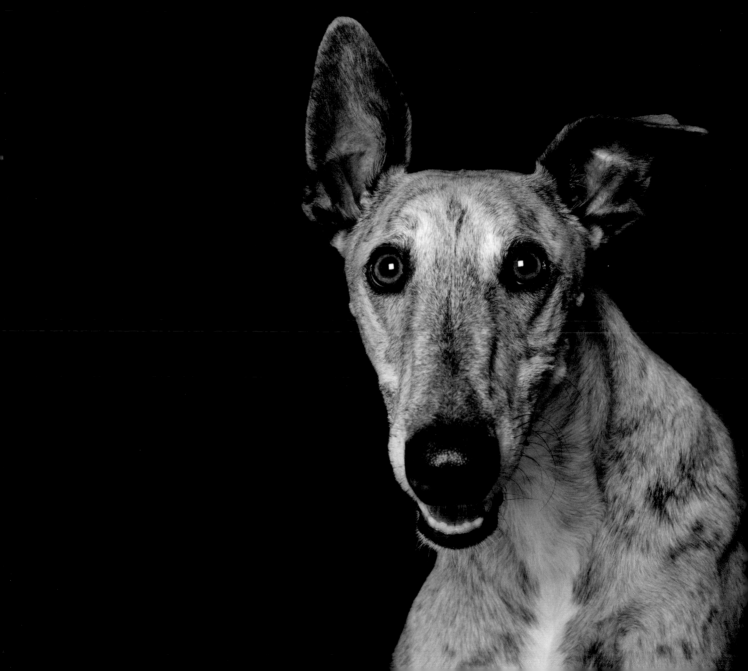

REX

4 years old

Humans:
Bryn & Akiko

We visited the Shenton Park Dog's Refuge Home and fell in love with all the dogs there, so we filled in the forms and waited for them to give us a list of dogs we could adopt. Due to the fact we had never had a dog before, we were only offered three to choose from. One was a particularly aloof greyhound named Luther.

When we met him, he showed precisely zero interest in us. The staff told us his story: he was an ex-racer that had been mistreated in the past, and had been waiting to be adopted for more than a year. He'd become one of their long-term residents, and all the staff were fond of him. We felt so sorry for Luther, despite his lack of interest in making friends with us, that we decided to take him home.

We renamed him Rex and, at first, he was a shy boy, mostly hanging out in the bathroom. Over a few weeks, he started to come out of his shell, following us around the house and, eventually, becoming our shadow.

Rex never really enjoyed the company of other dogs, he was more his own man, but he became inseparable from us, teaching us that, even though all dogs are amazing, all other dogs exist just half a ring below the lazy couch potato that is the greyhound.

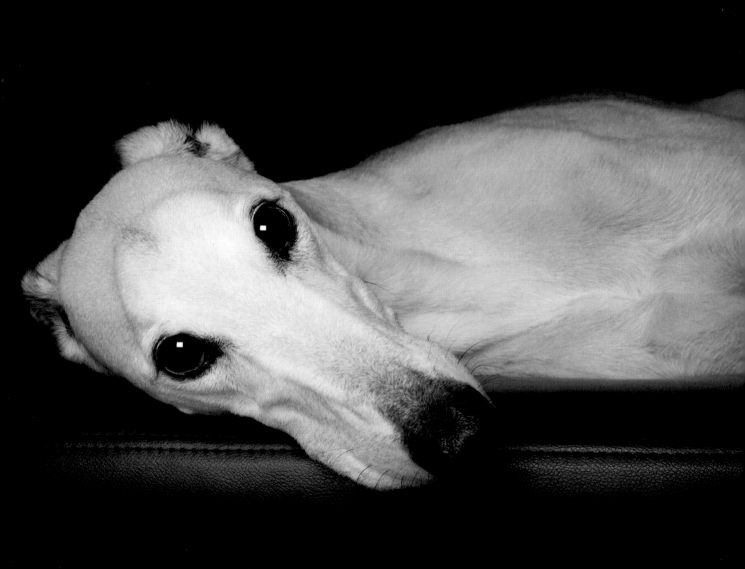

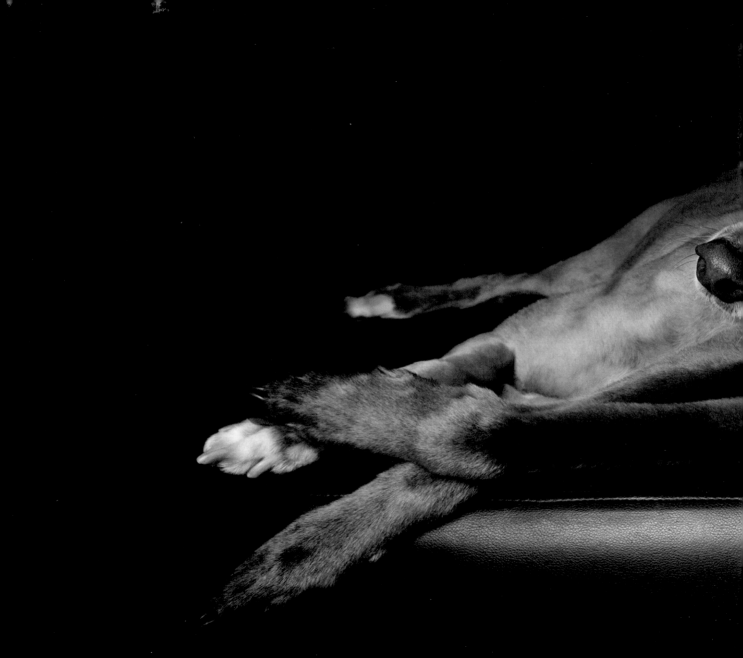

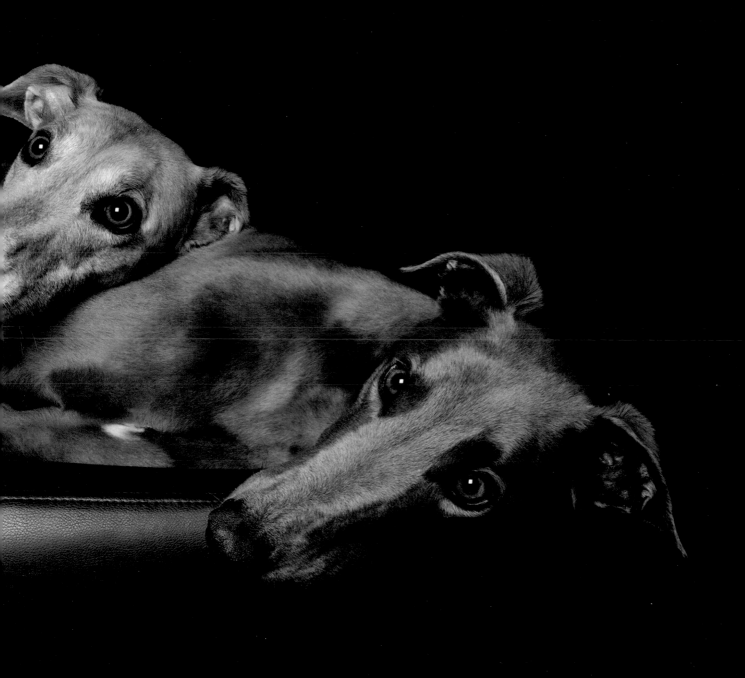

ACKNOWLEDGMENTS

First and foremost, thanks must go out to every person who has worked for, or volunteered in, greyhound rescue. Canine rescue can feel like a thankless task but the difference you make to each and every greyhound that finds a forever home is immense. You are saviours and your dedication is recognised.

Second, thanks go out to those who have adopted a hound and provided stability and love. The relationship you all have with your greys, and the comradery you feel with other grey owners, makes you part of the club. A club that has discovered an awesome dog breed and everything they offer.

Thanks to my beloved clients, who visited my studio with their greyhounds for portrait photos and participated in this book. Greyhounds make exceptional pets, and raising awareness about this is a team effort. I know we are all on the same page in wanting to find more homes for this beautiful breed.

A big thanks to my patient publisher, Katie Stackhouse, for bringing the concept of this book to me. I really appreciate your care for animals and willingness to reach people with the adoption message through print. Thanks also to Lachlan McLaine and Jane Waterhouse from ABC Books, for your work on *For the Love of Greyhounds.*

Thanks to my own beloved greyhound, Pixel, and greyhound x, Pip. I know I will have to read this out aloud to you, and that's totally ok ... you girls are the light in my life.

Special thanks to Deb, who is the best dog Mum in the world.

And lastly, to all of my greyhound friends, past and present ... I love you.

ABOUT ALEX CEARNS

Dogs Today magazine in the United Kingdom calls Perth-based photographer, Alex Cearns, 'one of the greatest dog photographers in the world'. Alex is the Creative Director of Houndstooth Studio and specialises in capturing portraits that convey the intrinsic character of her animal subjects.

Alex has been photographing greyhounds in her studio for several years. Their lines, form and quirky natures make them one of her favourite canine subjects. She has completed greyhound specific photography projects, has written articles about retired racing greyhounds for magazines, has raised funds for greyhound rescue, has provided her images for pro-greyhound adoption marketing and has provided commentary to organisations seeking endorsement for greyhound rescue. She photographs for a number of greyhound rescue organisations.

Alex works with around 40 Australian and international animal charities and conservation organisations, and is the recipient of more than 200 awards for photography, business and philanthropy.

Inspired by the joy of working with animals, Alex's philanthropy and passionate advocacy for animal rescue has earned her high regard among Australia's animal lovers and a strong following on social media. She regularly appears in print media and on radio and television, sharing her passion for supporting rescue animals.

Alex is the Australian Ambassador for Tamron's Super Performance Series Lenses, and a Brand Ambassador for Spider Holster and Seagate. A self-confessed crazy dog lady, Alex loves to hug all animals, especially her three rescued fur kids, Pip, Pixel and Macy.

Website www.houndstoothstudio.com.au

Facebook www.facebook.com/HoundstoothStudio

OTHER BOOKS BY ALEX CEARNS

Mother Knows Best (May 2014, Penguin)

Joy: A Celebration of the Animal Kingdom (December 2014, Penguin)

Things Your Dog Wants You to Know (December 2015, Penguin)
with Laura Vissaritis, dog behaviourist

Zen Dogs (October 2016, HarperOne, an imprint of HarperCollins)

Perfect Imperfection (March 2018, ABC Books)

GREYHOUND RESCUE

A percentage of royalties from the sale of *For the Love of Greyhounds* will be donated to various greyhound rescue organisations as directed by the author, Alex Cearns.

By purchasing *For the Love of Greyhounds*, you are making a difference to the lives of greyhounds, and are contributing to a valid cause.

Should you wish to adopt or foster a greyhound, here are some places to visit online:

Nationwide

www.egreyhound.com.au

www.gumtreegreys.com.au

GREYHOUND RESCUE

South Australia

www.facebook.com/sagreyhoundadoption

www.facebook.com/mygreytobsession

www.gapsa.org.au

Victoria

www.greyhoundsafetynet.org

www.gippslandgreyhounds.com

www.gap.grv.org.au

www.amazinggreys.com.au

Tasmania

www.brightside.org.au

www.gaptas.org.au

New South Wales

www.greyhoundrescue.com.au

www.friendsofthehound.org.au

www.gapnsw.com.au

www.clawsnpawsrescue.org.au

www.gapnsw.org.au

Western Australia

www.greyhoundangels.com

www.greyhoundadoptionswa.com.au

www.greyhoundsaspets.com.au

Queensland

www.facebook.com/Greys4PetsInc

www.greyhoundsnewbeginnings.org.au

www.gapqld.com.au

Northern Territory

www.grant.org.au

New Zealand

www.rehoming-greyhounds.org

www.greyhoundsaspets.org.nz

www.arananimalrescue.org.nz

The ABC 'Wave' device is a trademark of the
Australian Broadcasting Corporation and is used
under licence by HarperCollins*Publishers* Australia.

First published in 2018
by HarperCollins*Publishers* Australia Pty Ltd
ABN 36 009 913 517
harpercollins.com.au

HarperCollins*Publishers*
Level 13, 201 Elizabeth Street, Sydney, NSW 2000, Australia
Unit D1, 63 Apollo Drive, Rosedale, Auckland 0632, New Zealand
A 53, Sector 57, Noida, UP, India
1 London Bridge Street, London, SE1 9GF, United Kingdom
Bay Adelaide Centre, East Tower, 22 Adelaide Street West, 41st Floor, Toronto, Ontario, M5H 4E3, Canada
195 Broadway, New York, NY 10007

A catalogue record for this book is available from the National Library of Australia

ISBN: 978 0 7333 3924 0 (hardback)
ISBN: 978 1 4607 0969 6 (ebook)

Cover design by Hazel Lam, HarperCollins Design Studio
Internals design and typesetting by Jane Waterhouse
Colour reproduction by Graphic Print Group, Adelaide
Printed and bound in China by RR Donnelley

The papers used by HarperCollins in the manufacture of this book are a natural, recyclable product made
from wood grown in sustainable plantation forests. The fibre source and manufacturing processes meet
recognised international environmental standards, and carry certification.